How to Take

GREAT DIGITAL PHOTOS *of Your*

FRIEND'S WEDDING

PATRICK RICE
MASTER PHOTOGRAPHER

Amherst Media, Inc. ■ Buffalo, NY

Published by:

Amherst Media, Inc.

P.O. Box 586

Buffalo, N.Y. 14226

Fax: 716-874-4508

www.AmherstMedia.com

Publisher: Craig Alesse

Senior Editor/Production Manager: Michelle Perkins

Assistant Editor: Barbara A. Lynch-Johnt

ISBN-13: 978-1-58428-199-3

Library of Congress Card Catalog Number: 2006930068

Printed in Korea.

10 9 8 7 6 5 4 3 2 1

TABLE OF CONTENTS

INTRODUCTION

Weddings are a time of celebration, a joining of not only two people, but also two families and their friends. Weddings are emotional and festive occasions that lend themselves naturally to photography. While most brides and grooms entrust a trained professional photographer to document this important day, these couples welcome and encourage the random snapshots taken by friends and family. The purpose

Weddings aren't just a time of celebration for the bride and groom—friends and family get just as caught up in the event as the couple. Photograph by Patrick Rice.

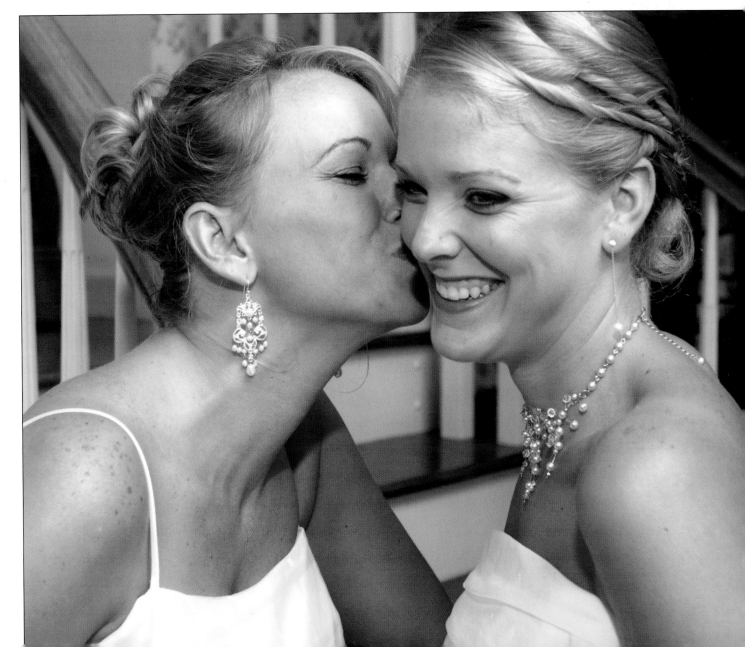

of this text is to improve the quality of the snapshots you create at your friend's weddings and make you an overall more proficient photographer. Through words and images, I hope to illustrate the important role you can play in preserving these priceless memories.

The advent of digital photography provides new opportunities and new challenges to all photographers. Although most amateur photographers do not have to understand the nuances of digital imaging as thoroughly as professional photographers do, having a solid grasp of photographic concepts and your equipment will make you more successful in all of your picture taking.

As a professional wedding photographer with nearly thirty years' experience, I feel that I am uniquely qualified to give any amateur shutterbug some guidance in taking better pictures. The professional photographic community has honored me with nearly every award given in the field, and I have won countless Best of Show and Photographer of the Year honors from several photographic associations. In the year 2000, the International Photographic Council, a division of the United Nations in New York City, bestowed on me their highest honor: the International Leadership Award. At the time, I was only the second wedding photographer to receive this distinction.

WORKFLOW

In professional photography, "workflow" is a collective term that refers to everything that happens to your digital images after the shoot. This could include downloading, backing up to CD or DVD, image manipulation and enhancement (like cropping or converting images to black & white), printing, framing, organizing the images in an album, etc.

HOW TO GET STARTED

Having spoken to dozens of photographers from across the nation, I've found that most digital photographers got started in the same way. Like anything in photography, you learn best by doing.

At my studio, we began the transition from film to digital by purchasing a high-end point-and-shoot digital camera. Then, we just started taking pictures. This first camera got us acclimated to using digital and taught us how to work with image files in the computer. As our confidence in digital cameras increased, we invested in better digital cameras, leading to our first professional digital SLR: the Canon D30. The image quality from the D30 really proved to us that the time was right to switch to digital image capture. We immediately began photographing all of our studio work with the D30. The results were incredible! We then began using the D30 for engagement sessions and outdoor high-school senior portraits. Again, the results surpassed our expectations.

Our last holdout for film was wedding photography. We began integrating our D30s (we now had three of them) on weddings, using them along with the film cameras. At the time, we were actually providing film capture for the client and digital capture just for us. We did this to not only give us confidence in using digital cameras in many diverse lighting situations but

Getting great wedding pictures takes some practice, so hone your skills as much as possible before the big day. Photograph by Patrick Rice.

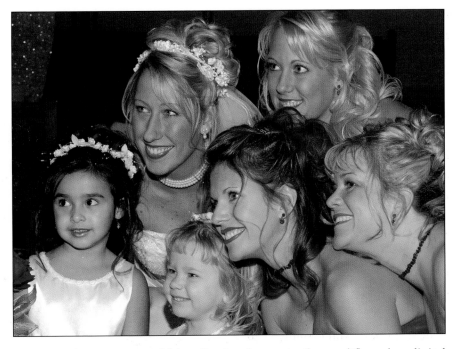

also to make sure we could handle the change in the workflow that digital imaging dictates.

If you're just getting started with your first digital camera, my advice is simply to start shooting. Taking pictures of your friends and family (indoors and out), candid images of people wherever you find them, and action shots (maybe at a local sporting match, concert, or other event) will help you hone the skills you need to take great pictures at a wedding. Besides gaining valuable experience in capturing images, you will begin to understand all of the other aspects related to digital—downloading and backing up your files, image manipulation, printing, etc.

HAVING FUN, TAKING GREAT IMAGES

At the heart of all photography should be having fun. People take pictures because they enjoy taking pictures, and photographers at every level love what they do. Taking pictures is a form of artistic expression that also allows us to record special moments in our lives. Wedding celebrations are some of the happiest occasions that one can be part of. Documenting the feelings and expressions on the wedding day helps those who were present to relive the emotions that they felt and lets those who weren't in attendance get a sense of the special event.

Wedding celebrations are some of the happiest occasions that one can be part of.

COMPLEMENTING THE IMAGES OF THE PROFESSIONAL PHOTOGRAPHER

In writing this text, I am *not* suggesting that any bride and groom should entrust their wedding photography to a nonprofessional. While amateur photographers who come to the wedding as guests may be capable of creating some wonderful pictures, the role of a professional wedding photographer is to record *all* of the special moments from the wedding day.

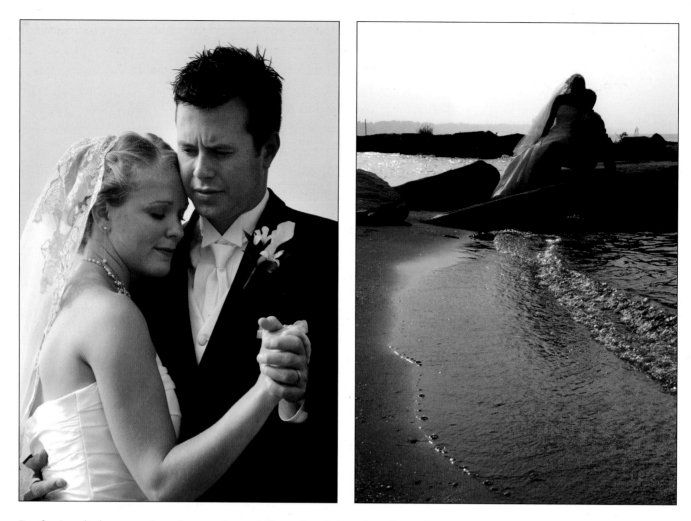

Professional photographers have unique skills and training that allow them to do this effectively and produce the top-quality images that a once-in-a-lifetime event deserves.

Professional photographers know how to pose people so they look their very best. Photographs by Patrick Rice.

Many times throughout the years, engaged couples have asked me to justify the expense of hiring a professional wedding photographer and not some much-better-than-average friend or relative who enjoys photography and is an avid camera buff. My answer is always the same.

First, I tell them that couples hire a professional wedding photographer for a number of important reasons—and not all of them directly relate to taking pictures. First, a professional wedding photographer is necessary to ensure both quality and consistency in the wedding photographs. A professional wedding photographer is not permitted to miss *any* important photo. I look at that engaged couple and ask them which pictures they would be okay with *not* having come out properly. The fact is that some couples never really consider the importance of hiring a qualified professional wedding photographer until it is put in these blunt terms.

Further, professional wedding photographers can anticipate important photographs even before they happen. They know where to be to get the best-possible images. This is because of extensive training and experience in photographing numerous weddings over the course of many years.

Concentrate on creating pictures that complement the professional wedding photographer's work.

Professional photographers also have the ability to pose individuals and groups in a way that looks the very best. This means that couples will usually be happier with their images because everyone in the photograph will look better. Professional photographers are also skilled at using light, another factor in creating truly flattering portraits.

Therefore, as a photographic hobbyist who wants to take great digital pictures at your friend's wedding, you should concentrate on creating pictures that *complement* the professional wedding photographer's work. Look to create pictures that the professional doesn't take—maybe a moment unfolding outside while he's creating portraits at the altar or a funny moment that occurs across the reception hall from where the photographer is shooting. Also, keep in mind that most professional wedding photogra-

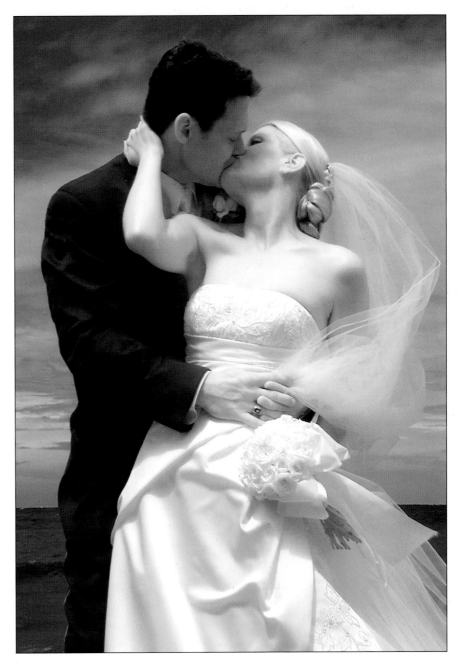

This is a professional image taken using a digital infrared camera. Images like this are beyond the technical abilities of most amateurs and illustrate the importance of hiring a professional as the principal photographer. Photograph by Patrick Rice.

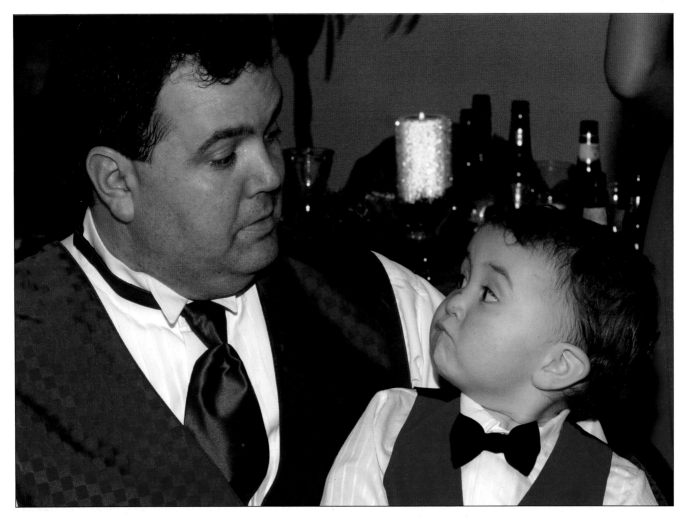

phers do not have the time to create informal small group pictures of guests throughout the evening at the reception. You have the advantage of knowing who should be included in a picture to make it especially meaningful to the bride and groom. Never assume that the couple communicated all of that information to the professional photographer—they would need a list several pages long to document every guest and relationship!

Most couples want the traditional wedding photos and a collection of truly candid images to provide a sense of what the wedding day was like. They want to see feelings and emotions in the photos. You may see something that the professional photographer doesn't see because they are concentrating on a shot that is deemed more important at that moment. Images like this will be well received by the bride and groom and treasured forever.

Candid images that capture moments they might have missed are always popular with the bride and groom. Photograph by Patrick Rice.

1. DIGITAL CAMERA BASICS

For candid portraits, a small point-and-shoot camera will do the job. Most people will just want 4x6-inch prints of these images, rather than the large wall-size prints they might request of a more formal portrait. Photograph by Patrick Rice.

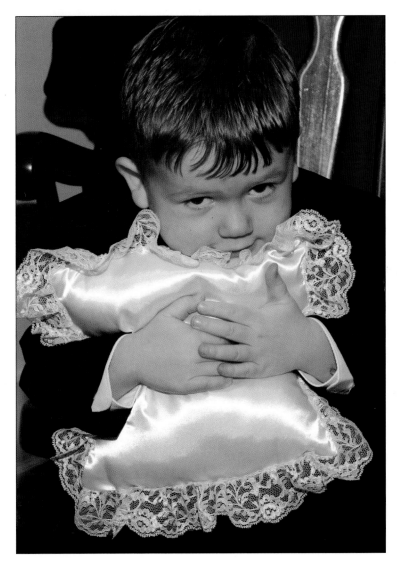

The first ingredient in great digital photography is—you guessed it—a digital camera. As a guest who will be taking supplementary shots at the wedding, you don't need to have the latest, greatest camera on the market to get excellent results. What's more important is that you have a reliable camera and that you know how to use it. After all, you don't want to be fumbling around looking for buttons or scrolling through menus when a great shot appears before you!

If you decide you want to buy a new camera for the event (many people *do* get the urge to upgrade their equipment when a special event is on the horizon), buy it well in advance of the wedding and spend some time practicing with it before the big day. Even if you're an experienced digital photographer, every model will have different options and ways of accessing each setting, so you'll want to be familiar with these in advance.

Whether you buy a new camera or plan to use your current one, however, the following issues should be considered.

MEGAPIXELS AND PRINT SIZES

You may wonder if your camera is "good enough" to take pictures that the bride and groom will be happy with. What this boils down to is whether or not you can make good-looking prints from your camera and how much you can enlarge your images and still achieve good print quality. This is, essentially, an issue of resolution.

When your camera captures a digital image, what it is actually capturing is millions of tiny dots of color called pixels. When these pixels are viewed collectively, they create the pho-

tograph we see. The more pixels a camera captures, the more detail there will be in the image. When there's a lot of detail in an image, you can make larger prints without worrying that they will look bad.

The resolution of a camera (the maximum number of pixels per image it can produce) is denoted in terms of megapixels. "Megapixel" is a fancy way of saying 1,000,000 pixels. Cameras that boast three, four, five, or more megapixels really mean three million, four million, five million, or more pixels in the camera's sensor (and, thus, in the images it captures). These pixels are what gather the information or data that helps to form an image by the camera.

Unfortunately, not all camera manufacturers measure their pixel count in the same manner. Some cameras utilize interpolation to determine the number. In layman's terms, interpolation is a built-in process that essentially increases the pixel count (usually doubles) without changing the physical number of pixels in the camera's sensor. This results in more pixels, but they often aren't as accurate as they would be otherwise; this can yield a reduced image quality.

As a result, the real test of a camera is to determine its maximum acceptable print size. After all, if you do not like the quality of your photograph when printed at an 8x10-inch size (or whatever size you like to print), nothing else really matters. Digital photographs that are enlarged beyond the capabilities of the camera tend to look blurry or pixelized.

Today, even low-end digital cameras usually feature at least a 3-megapixel sensor, which should be just fine for producing up to 8x10-inch prints—and maybe even a bit larger. Again, the real test is to take some pictures and make some prints. And here's another thing to consider: given the types of images you'll be shooting, smaller print sizes may be all that are needed. After all, while the couple may buy a huge wall print of their formal portrait, the bride probably won't need a huge print of her college roommate eating cake with her second cousin. Even some of the big moments of the wedding (the bouquet toss, best man's toast, etc.) are rarely presented in large print sizes.

PIXELIZATION

Pixelization sometimes occurs when you make a print that exceeds the capabilities of your image file. This image flaw is characterized by rough or jagged edges in your image where there should be sharp lines (particularly curved or diagonal lines).

FILE FORMAT AND IMAGE-QUALITY SETTING

Most digital cameras give you some choices as to the file format and image-quality setting you would like to use when shooting.

The file format is essentially the language in which the digital image is written. It tells applications, like image-editing software or web browsers, that your file is a picture (rather than a text file, for example) and how it should handle all the data in the file to display it correctly on the screen. The file format is indicated by a tag (.TIF, .JPG, etc.) added after the file name.

FACING PAGE—Kids have great reactions to weddings, so keep an eye open for shots of the little ones throughout the day. Photographs by Richard Frumkin (top left) and Patrick Rice (top right, bottom).

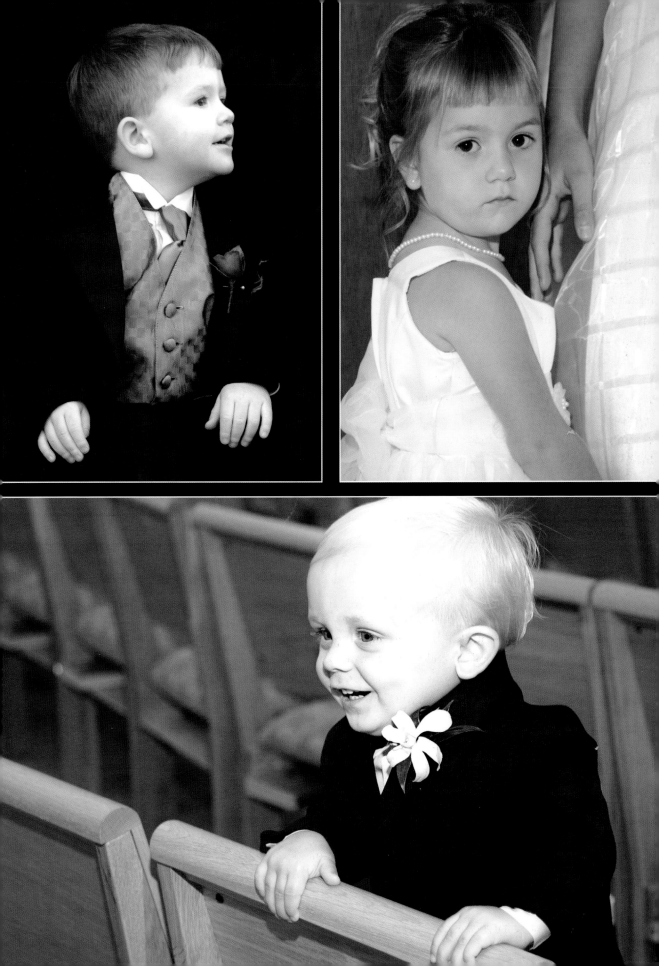

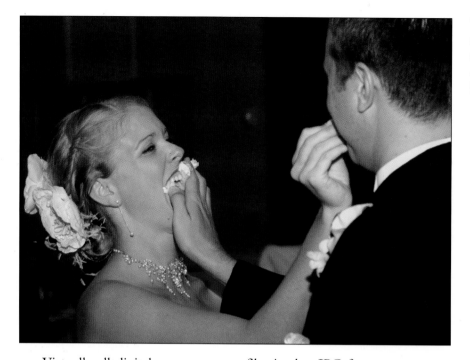

Virtually all digital cameras create files in the .JPG format; some can also create .TIF files or .RAW files. For the ultimate in image quality, many professionals choose to shoot in the .RAW format. These files, however, are quite large (they require a lot of memory to process and store) and can slow down your shooting because each image will take longer to process. For this reason, there are many other professionals who prefer to shoot in the .JPG format—especially in situations where fast shooting is required, like at a wedding.

The image-quality setting on your digital camera determines whether the camera will create the largest, highest-quality files it is capable of producing or some smaller, lower-quality versions. If you switch to a lower-quality setting, the files will be smaller. This means that each image will process more quickly, and you'll be able to fit more on each card. However, because these images will contain fewer pixels, the maximum print size you'll be able to achieve will also be reduced. For this reason, most professionals who choose to shoot in the .JPG format leave their cameras at the Large or Highest Quality setting.

There's a great deal of variety when it comes to lenses . . .

LENSES

There's a great deal of variety when it comes to lenses, and a lot of what you have to choose from will depend on your camera.

Fixed. If you have the least-expensive kind of point-and-shoot camera, you'll probably have a fixed lens that doesn't zoom. This means that in order to make your subject larger in the frame, you have to reduce the distance between the subject and the camera (either by calling them closer to you or moving in closer to them). In a wedding situation, this can be tricky.

Zoom. A better point-and-shoot choice is a camera with a zoom lens. This type of lens is permanently attached to the camera (it's not inter-

changeable), but it allows you to zoom in on the subject for a tight shot or zoom out for a broader image that includes more of the environment. This gives you more options when shooting—especially since it allows you to take close-up photos from a distance. Staying farther away from your subject lets you work on the sly, capturing more natural expressions (and not causing those camera-shy folks to turn away from the camera).

One specification you'll see listed with lens data is optical (or actual) zoom and digital (or enhanced) zoom. The number you want to look at is the optical value. This is the amount of enlargement actually produced by the lens itself. "Digital zoom" is not really zoom at all—it's a software func-

Staying farther away from your subject lets you work on the sly.

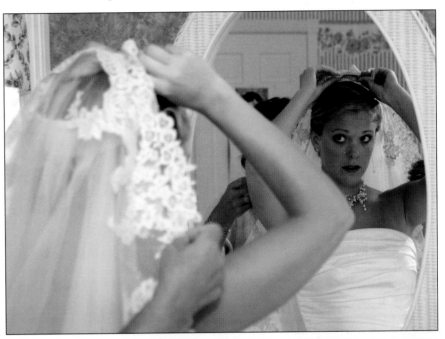

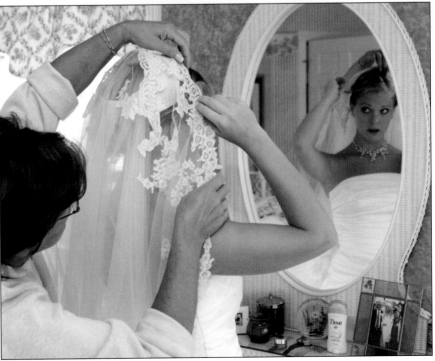

With a zoom lens, you can capture different views of a scene without having to change your camera position. Photographs by Patrick Rice.

Be sure to document any unique articles of attire the couple might have chosen for their wedding day. Photographs by Travis Hill (left) and Patrick Rice (right).

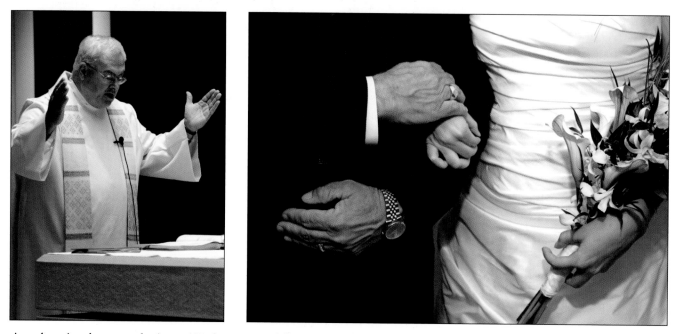

tion that simply crops the image in the camera. This reduces the image quality. If you want to move in more tightly on a subject than you can with your lens, you're better off either moving your camera closer to the subject or, if that's not possible, cropping the image later using your computer where you have more control (see page 68).

Using a large memory card reduces the amount of time during the day that you'll be out of commission while changing to a fresh card. Photographs by Patrick Rice.

Interchangeable. In recent years, the prices on digital SLRs have dropped dramatically, making them a realistic choice for many amateurs. These cameras offer the ultimate flexibility, because they employ lenses that can be removed and switched. You can select fixed focal-length lenses or zoom lenses, telephotos or wide angles—whatever you want. This means you'll have more gear to tote around and, because these systems are larger, you won't be as able to shoot without people noticing. However, most photographers find the enhanced controls and lens choices to be worth the added effort.

MEMORY CARDS

Once the image sensor has captured the photograph, it transfers the data to the memory card, where it is stored. Unlike film, memory cards can be used again and again (which is a good thing, since they aren't exactly cheap).

Most consumer cameras use what are called "flash memory" cards. These are solid-state cards, meaning there are no moving parts; electronics rather than mechanics do the work. This makes them very reliable because there's less to go wrong. I have met three photographers who have left such cards in the pockets of their trousers and sent them through the washing machine and dryer without harming the card or the images recorded on them! These cards are also lightweight and noiseless—and they save images quickly, meaning you can keep shooting without waiting for the camera to write images to the card.

Memory cards are labeled (and priced) according to their storage capacity. The smallest ones hold only 8 megabytes (MB) of data, while the largest now hold over 4 gigabytes (GB). The size of your camera's image sensor (see page 11), the file format you choose (see page 12), and the amount of compression you set your camera to use (sometimes called the image-quality setting; see page 13) will determine how many images a particular memory card will hold.

With digital, people tend to shoot a lot more images than they did on film, so don't skimp—with a large card, you can shoot for hours and never have to swap it out (so you'll never miss a shot). Still, I would recommend that you buy a couple of extra memory cards just in case.

Memory cards are labeled (and priced) according to their storage capacity.

BATTERIES AND BATTERY LIFE

Today, photographers are blessed with many options when considering batteries for their digital cameras. Familiarize yourself with your camera's battery compartment and always have spare batteries at the ready. Batteries will always die at the most inopportune times—and with wedding photography, you probably won't get a second chance to take a missed photo.

Alkaline. Many of the popular digital cameras require simple AA batteries in ether a pair or quad configuration. Alkaline batteries are excellent for use in all digital cameras that will accept them. The only downside with using alkaline batteries is the life expectancy and replacement cost. Some digital cameras are battery hogs—in other words, they use up batteries at a rapid pace. At $4 or more for a set of batteries, the added expense of battery replacement could discourage you from taking as many pictures as you would like.

Ni-Cad. Ni-Cad (Nickel Cadmium) batteries have been the standard for rechargeable batteries for many years. Ni-Cads are expensive initially,

REFORMATTING

After you've transferred all the images off a card and backed them up (at least once) to CD-R or DVD-R, return the card to your camera and select the "format" option from your in-camera menu (consult your camera's manual for more information on this) to remove all the images. Formatting the card, rather than just deleting all the images, completely resets the card and helps prevent potential problems and disk errors.

compared to alkaline batteries, but can be recharged over and over again. As a result, they more than pay for themselves in a short time.

There are, however, two major flaws with using Ni-Cad batteries to power digital cameras. First, Ni-Cad batteries generally do not hold a charge as long as a set of fresh alkaline batteries. In other words, when using Ni-Cads, you won't get as many pictures before you have to recharge the batteries. Therefore, I would recommend carrying at least two sets of Ni-Cad batteries to any wedding you may choose to photograph.

I would recommend carrying at least two sets of Ni-Cad batteries.

The second problem with Ni-Cad batteries is that they can develop a chemical memory. This chemical memory is the number of images that the battery can record before recharging. If you recharge your Ni-Cad batteries before they are completely discharged, the next time you go to use those batteries you will get fewer pictures before the batteries need to be recharged again. This means your picture-taking capacity decreases over time, so you need to change the batteries more often.

NiMH. Over the past few years, a new rechargeable battery technology has been developed called Nickel Metal Hydride (NiMH). NiMH batteries have good longevity without the chemical memory concerns of Ni-Cad batteries. These batteries are also initially expensive but well worth the

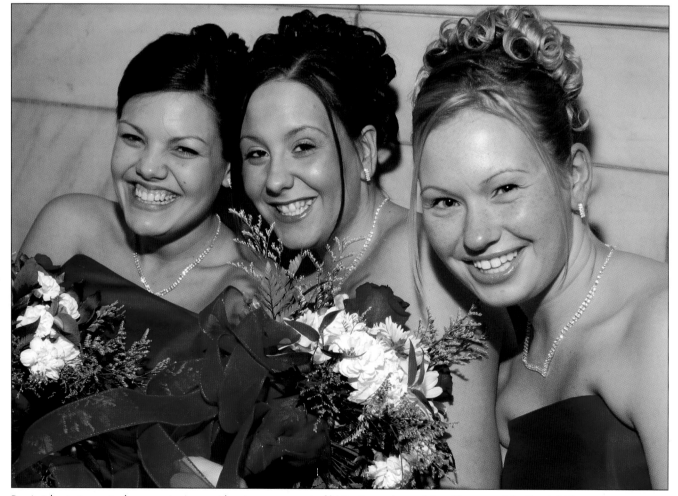

Don't risk missing a single moment—carry at least one spare set of batteries to the wedding. Photograph by Travis Hill.

TIPS FOR BETTER BATTERY LIFE

An important consideration with regard to battery life is how you have set up your digital camera. Most digital cameras have settings for how bright the illuminated image is on the camera's LCD screen, as well as the duration of time that the image is displayed. Reducing the brightness and display time will increase your battery life. Most digital cameras also have an automatic shut-off feature that can be set for different lengths of time. This is a battery-saver function that can easily extend your ability to take pictures using any type of batteries.

investment after only a handful of uses. Another advantage of NiMH batteries is that many of the brands available can be recharged very quickly—in as little as one hour. While Ni-Cad batteries usually require several hours of charge time to restore them to full power, with these new NiMH quick-chargers you can recharge your batteries during a break in the action at a wedding and bring your batteries back to full power for when they are most needed. Some NiMH batteries even have automobile chargers so that you can recharge them while you drive. I routinely recharge my batteries on the drive between the church and the reception on a wedding day.

Great pictures often happen when you least expect them, so you need to be constantly aware and ready to shoot. Photograph by Patrick Rice.

2. EXPOSURE

Digital imaging has revolutionized photography, giving us the power to enhance our images in amazing ways and rescue problem images that, if shot on film, would have been a total loss. Given all this advanced technology at our fingertips, it can be tempting to get a little sloppy when it comes to exposure—we just figure, "Oh, I'll fix

For many scenes, the automatic mode will work just fine. Photograph by Anthony Zimcosky.

For very dark or very light scenes, the manual mode is often needed in order to capture the scene accurately. Photograph by Patrick Rice.

that later." However, spending ten minutes in front of your computer to fix a problem you could have *avoided* creating in the first place by taking two seconds to adjust your cameras settings . . . well, it just doesn't make sense. Additionally, your "fixed" image will probably never look quite as good as if you'd just shot it properly. In this chapter, we'll look at the things you need to consider.

SHOOTING MODES

Automatic. If you are new to photography, you may want to leave your camera in the automatic mode. This means that the camera will make all of the exposure decisions for you. While there are some situations in which this may not work well (very light or dark subjects or scenes may confuse the camera's metering system), by and large you'll probably get acceptable results.

If you're a more experienced shooter or ready for a new challenge, you may want to try out some of the other modes. These vary from camera to camera, so check your user's guide to see which features are offered on your model.

Program. The program mode (usually indicated by a "P") is similar to the auto mode, but it usually allows you to exercise control over some camera settings (like white balance, ISO, etc.). These are covered in detail later in this chapter.

Shutter Priority. In this mode (commonly indicated by "Tv"), you select the shutter speed and the camera selects the best aperture setting to match the brightness of the scene. Choose a short shutter speed to freeze moving subjects or a long one to blur them. Shutter speed is covered in detail later in this chapter.

Aperture Priority. This mode is usually denoted by an "Av" on the exposure dial or menu. It allows you to select the aperture while the camera sets the shutter speed. Aperture is covered in detail later in this chapter.

Manual. In this mode (indicated by "M"), you control all the settings, giving you complete control over the exposure.

Portrait. When shooting in the portrait mode (usually indicated by the profile of a face), the camera selects a wide aperture to keep the subject in focus while blurring the background.

Landscape. In the landscape mode (usually indicated by a mountain and clouds icon), a narrow aperture is selected to keep as much as possible of the scene in focus. This can result in longer shutter speeds, so it's advisable to use a tripod to minimize camera movement. This mode works well for vast landscape scenes.

Night Portrait. The night portrait mode is usually denoted by a profile of a face with a moon and stars next to it. This mode is used to take a

well-exposed image of a subject against a night (or other low-light) scene. To do this, the camera's flash is used to illuminate the subject. The shutter, which is usually matched to the duration of the flash, is then left open a bit longer to allow the less powerful ambient light (light from the moon, street lamps, windows, etc.) to register in the image.

Artistic Effects. Often indicated by a palette and brush, this mode allows you to select from color options that may include shooting in black & white, sepia-tone, vivid color (enhanced color saturation and contrast), or neutral color (subdued color saturation and contrast).

Panoramic Mode. In the panoramic mode, the camera helps you create a series of slightly overlapping shots that can later be combined into one big image using your image-editing software. This can be done either horizontally or vertically.

Create a series of slightly overlapping shots that can later be combined into one big image . . .

With people on the move, shooting in the continuous mode can help ensure that you get at least one good shot. Photograph by Patrick Rice.

Continuous. This mode is normally indicated by a stack of rectangles (photos) and lets you shoot successive frames for as long as the shutter button is pressed (until the camera or memory card runs out of memory). This mode can be useful for hard-to-time action shots, like the bride tossing her bouquet.

APERTURE AND SHUTTER SPEED

If you decide to work in the aperture-priority, shutter-priority, or manual mode to get better control over your images, here's what you need to know to select the right settings.

Aperture. The aperture you choose determines two things: the amount of light that is allowed to strike the image sensor and the depth of field in your image.

Exposure. The smaller the aperture, the less light reaches the image sensor; the larger the aperture, the more light reaches it. With each change in the aperture, the amount of light striking the film/sensor is either doubled or halved. Though it may seem counterintuitive, there is actually an *inverse* relationship between the size of the aperture and the number used to represent it. For example, an aperture setting of f/16 is *smaller* than one of f/2.5. It may be helpful to review the chart below to better understand the relationship between the aperture size and the amount of light used to make the exposure.

f/2.8—Twice as much light as f/4
f/4—Half as much light as f/2.8, twice as much light as f/5.6
f/5.6—Half as much light as f/4, twice as much light as f/8
f/8—Half as much light as f/5.6, twice as much light as f/11
f/11—Half as much light as f/8, twice as much light as f/16
f/16—half as much light as f/11, twice as much light as f/22
f/22—Half as much light as f/16

The other half of the exposure equation is shutter speed. Shutter speed, which will be covered in detail below, determines the duration of time during which light is allowed to enter the camera. If you make your aperture *wider* (allowing more light to enter the camera), you will need to *reduce* your shutter speed (allow that larger amount of light to enter for less time) to maintain the same exposure. Conversely, if you reduce your aperture, you will need to select a longer shutter speed to maintain the same exposure. If you shoot in the aperture-priority setting, the camera will automatically select what it deems to be the correct shutter-speed setting for the scene. If you shoot in the manual mode, you can select this setting yourself.

Depth of Field. The camera's aperture setting also controls the amount of depth of field. This is the area between the nearest and the farthest points from the camera that are acceptably sharp in the image. The smaller the aperture, the more depth of field in the photograph. This means more of the

The other half of the exposure equation is shutter speed.

background of the image remains in focus. Using a wider aperture produces less depth of field. This can be good for keeping your subject in focus while blurring out a distracting or unimportant background area.

Shutter Speed. As noted above, the shutter speed refers to the amount of time that the camera's shutter remains open, allowing light to strike the image sensor. The shutter speed is usually rated in fractions of a second, though photographers sometimes use long exposures (a second or several minutes, for example) to photograph in low-light situations.

The longer the shutter speed, the more light reaches the sensor; the shorter the shutter speed, the less light reaches the sensor. Each change in the shutter speed means that the amount of light striking the sensor is doubled or halved. It may be helpful to review the following chart.

Using a wider aperture produces less depth of field. This keeps your subject in focus while blurring out a distracting or unimportant background area, as seen in the above images.

1 second—Twice as much light as $\frac{1}{2}$ second

$\frac{1}{2}$ second—Half as much light as 1 second, twice as much light as $\frac{1}{4}$ second

$\frac{1}{4}$ second—Half as much light as $\frac{1}{2}$ second, twice as much light as $\frac{1}{8}$ second

$\frac{1}{8}$ second—Half as much light as $\frac{1}{4}$ second, twice as much light as $\frac{1}{15}$ second

$\frac{1}{15}$ second—Half as much light as $\frac{1}{8}$ second, twice as much light as $\frac{1}{30}$ second

$\frac{1}{30}$ second—Half as much light as $\frac{1}{15}$ second, twice as much light as $\frac{1}{60}$ second

$\frac{1}{60}$ second—Half as much light as $\frac{1}{30}$ second

Short shutter speeds are typically used to control exposure in brightly lit situations or to freeze moving subjects. Short shutter speeds also help to alleviate the effects of camera shake, a blurring that sometimes occurs due to camera movement when handholding the camera.

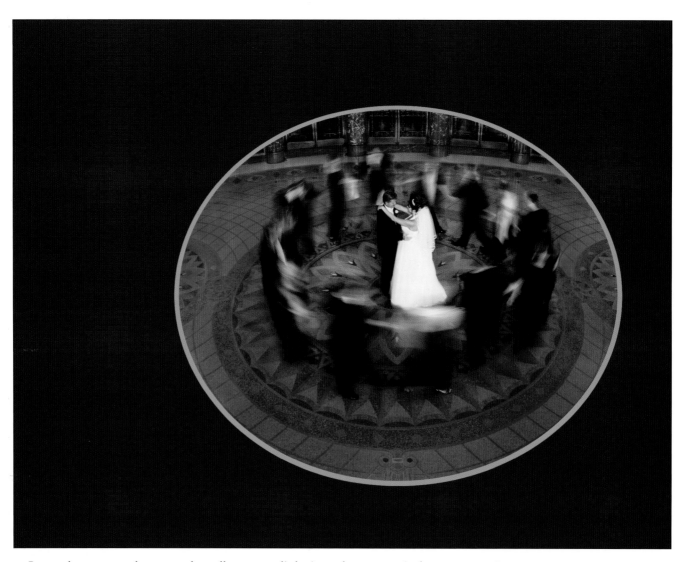

Long shutter speeds are used to allow more light into the camera in low-light situations. They can also be used to blur moving subjects, accentuating the motion as a blur across the frame. When using long shutter speeds, there is an increased risk of blurring due to camera movement. Therefore, the camera should usually be tripod-mounted or otherwise stabilized.

As noted above, aperture and shutter speed have an inverse relationship. If you need to use a shorter shutter speed to freeze action, you can use a bigger aperture to compensate for the reduction in light entering the camera. If you want to use a long shutter speed to blur action, you can select a smaller aperture to compensate for the increase in light entering the camera. As discussed below, your ISO setting will also have an effect on exposure.

Long shutter speeds can be used to blur moving subjects, like this wedding party dancing around the bride and groom. Here, the look of a mat with a round opening was added in Adobe Photoshop, creating an elegant presentation. Photograph by Patrick Rice.

ISO SETTINGS
The ISO setting on your digital camera is similar to what was referred to as the film speed with film cameras. In the days of film photography, you would make a choice about what film speed to load into your camera based on the subject matter and conditions under which you would be taking pictures—and you were stuck with that choice until you reached the end of the

roll. With your digital camera, you can choose the appropriate ISO setting based on the situation and change it throughout the day—even image by image—depending on the results you are trying to achieve. This is a huge advantage over using a film camera.

Essentially, the higher the ISO setting you select, the more sensitive your camera will be to light. This allows you to work in situations with less light (say, inside a church) and still use a short enough shutter speed to freeze the action of moving subjects. However, the higher the ISO setting you use, the more noise (a speckled effect similar to film grain) you will see in your images. Whether or not this is objectionable depends on your tastes and the results your camera produces. Some experimentation with different settings before the wedding will let you know what to expect at each ISO setting.

With digital imaging, you can adjust your ISO setting as you move from one location to another. Photograph by Patrick Rice.

The ISO setting you choose should be based on the shooting conditions you are working in as well as the size of the picture you intend to print. For example, most candid pictures will probably never need to be any bigger than 4x6 inches; at this print size, noise will be less visible, so it's not much of an issue. However, if you were taking a family picture or some other posed grouping of people, you might want to use a lower ISO setting if possible. This is because the bride and groom might request a 5x7, 8x10, or even larger print from one of these files. As digital prints are enlarged, noise becomes more apparent, so minimizing it by selecting a lower ISO will produce more appealing prints.

WHITE BALANCE

Lighting considerations for digital photography will be discussed in more detail in the next chapter. However, there is one light-dependent camera setting you'll need to adjust before making your exposure. This is called the white balance.

So what is white balance? Well, to understand it you need to know that not all light is created equal. Some light (like at sunset) is quite red/orange, other light (like from household lightbulbs) is very yellow, still other light (say, from fluorescent bulbs) is actually very green. Our eyes are very adaptive and quickly compensate for different lighting conditions so that colors

AUTOMATIC VS. FIXED WHITE BALANCE SETTINGS

In the automatic white balance mode, the color balance will change based on the range of colors in the scene. If you take a picture of the bride in her white gown standing next to the groom in his black tuxedo, the automatic white balance mode should provide you with a nice, pure-white gown. However, if one of the guests who is wearing a red dress stands next to the bride, you will probably see a blue color cast in the white gown. This is because the automatic white-balance mode may cause the camera to overcompensate for all of the red color it is sensing and add too much blue to the picture. Stand a guest in another color dress next to the bride, and you may see the bride's gown take on still another color cast. Setting the camera's white balance to one of the fixed white-balance settings can alleviate this problem, rendering the bride's dress a consistent color in all pictures taken under those conditions—regardless of the surrounding colors.

Choosing a white-balance setting that matches the light in the scene ensures accurate colors. The images here were shot under tungsten light. Using the daylight white balance setting produced a yellow/orange color cast (left). Switching to the tungsten setting compensates for this and renders the scene more as it appeared to the eye (right). Photographs by Patrick Rice.

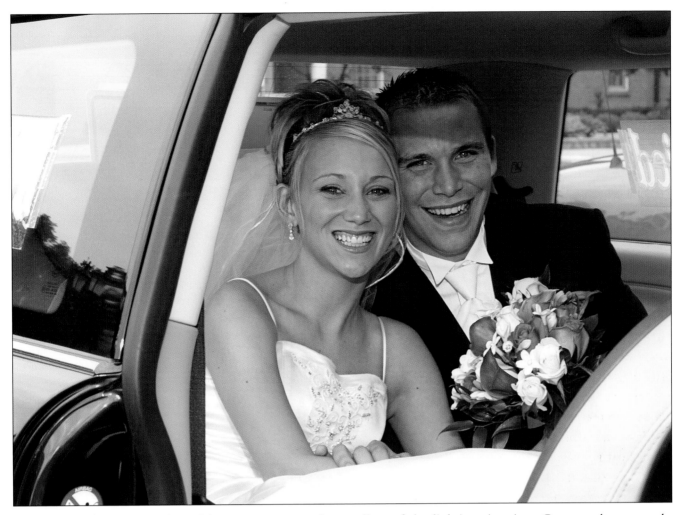

A shot made through the open door of the limousine can be a big hit. Photograph by Anthony Zimcosky.

appear natural regardless of the lighting situation. Cameras, however, do not; unless we compensate for these shifts, the colors in our images will have casts that match the color of the light. This is what white balance allows us to do. Essentially, it applies a small change to neutralize the colors in our images so that they appear the way we saw them with our eyes.

To maintain accurate color, the digital photographer can change the white balance setting on his camera at any time to match the lighting conditions present. Digital cameras have several white balance choices to match any lighting situation.

Automatic. The easiest of these settings is the auto setting. With your camera set to automatic white balance, the camera will evaluate the scene or subject before it and select the setting it decides is best. Usually, this is actually quite accurate. Therefore, it may be a good setting to select when you are in mixed lighting conditions (say, there's a mix of lamp light and window light) or when conditions are changing so rapidly that you don't have time to make manual adjustments (perhaps when photographing the departing bride and groom moving from inside the church, to outside on the steps, and then into their limousine).

Fixed Settings. If you're shooting in a consistent environment with one type of lighting (perhaps at a reception hall lit with incandescent bulbs),

you can select a specific white-balance setting to match that light. Most cameras offer sunny day, overcast, tungsten (household incandescent), fluorescent, flash, and other settings.

Custom White Balance. Many digital cameras have a custom white balance setting. This allows the photographer to meter a white area (a white wall, the bride's gown, etc.) and use that data as the standard for the setting in that scene. Check your camera's manual to see if your model offers this and, if so, how to set it.

When more than one kind of light illuminates a scene (here tungsten and window light), using a custom white balance setting is a good choice for producing accurate colors. Photograph by Patrick Rice.

When shooting candid images at a wedding, you won't have much choice when it comes to lighting—but you can still learn to know good lighting when you see it, and be ready to take advantage of it when possible. If you are taking more posed portraits, you can find just the right light. Doing so may require less effort than you'd think, and it can make a big difference in your images.

If you are taking more posed portraits, you can find just the right light.

QUALITY OF LIGHT

Light is either hard or soft (or somewhere in between). Hard light is harsh and produces sharp shadows (like those seen at noon on a bright, clear day). Soft light is gentle and produces faint shadows (like those seen on a totally overcast day). In general, portraits taken in soft light are more flattering. At weddings, you can find soft light in shaded areas (like under a tree or on a porch), in areas that are lit by windows—especially ones with frosted glass or sheer drapes. (*Note:* When sun is streaming directly through a window

LEFT—Hard light produces well-defined shadows on the subject's face. RIGHT—Soft light produces pale, sometimes nearly invisible shadows on the subjects' faces. Photographs by Patrick Rice.

and onto your subject, the light may still be hard.) When taking a posed portrait, finding softer light may be as easy as asking the subject to take a few steps into the shade of a nearby tree.

DIRECTION OF LIGHT

The best light for portraits comes from at least a little to the rear of the photographer. This means that the light is striking the front and/or side of the subject's face. Unless you want to create a silhouette, you should generally avoid light that comes from behind the subject. Again, achieving this goal can be as simple as asking your subject to turn around or turn to a different angle in relation to the light.

NATURAL LIGHT

Natural light can be used to create many appealing effects. Despite the control that working with studio lights provides, even professional photographers often prefer the simplicity of working with natural light.

The best light for portraits comes from at least a little to the rear of the photographer.

For best results, the primary light source that strikes the subject's face should come from behind or to the side of the photographer. Here, as the shadows reveal, it was a bit to the left. Photograph by Patrick Rice.

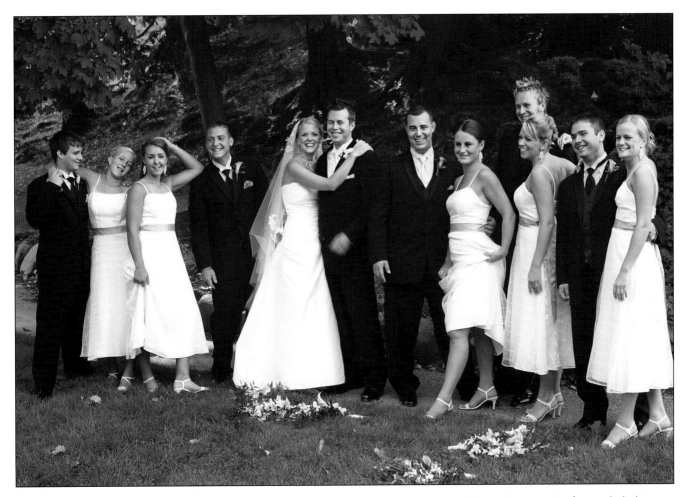

When taking people pictures during the day, you'll get the best results when you look for shaded areas. Photograph by Patrick Rice.

Overhead Light. When you are taking pictures outdoors, it is important to pay attention to where the light is coming from and what kind of shadows it is casting on your subjects. In particular, it is best to avoid situations where the light strikes the subject from above. This can create unpleasant shadows on the face—like dark shadows under the brows (what photographers call "raccoon eyes"). If you must shoot when the sun is high in the sky, look for situations where the light is blocked from overhead. The light at the edge of a clearing (with tall trees or branches overhead) is often ideal, as is the light on a porch.

Window Light. You can also use natural light indoors. Window light (or light through open doors) is often extremely flattering for portraits. Because windows tend to be large, the light is typically very soft. Windows, by their very nature, also produce light with good directional characteristics. This means that the shadows created by the light are very good for revealing the shape and texture of the subject, giving your pictures more of a three-dimensional look.

Subject placement is critical for effective window light pictures. Window lighting works best when the subject is turned slightly or completely toward the window and you are positioned perpendicular to the window. Start by having the subject standing with their shoulders perpendicular to the far edge of the window and facing you. Then, have them slowly turn

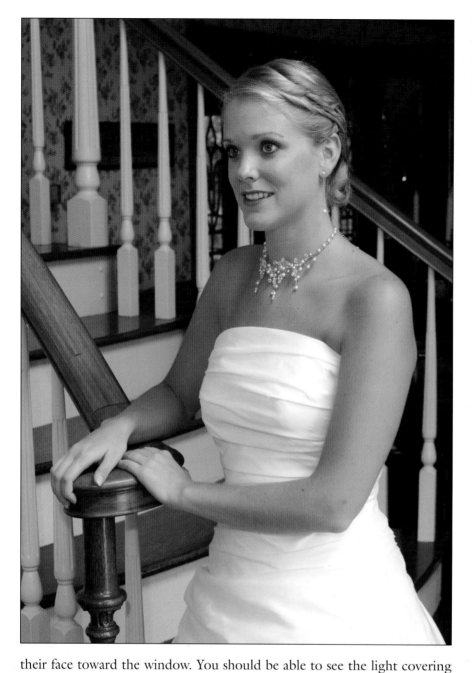

Window light skims across the subject from the side, revealing the shape of the subject's face and the texture on her gown. This gives the image more of a three-dimensional look. Photograph by Patrick Rice.

their face toward the window. You should be able to see the light covering the front of the face when they turn about 45 degrees toward the window. (*Note:* As discussed in chapter 5, you may wish to refine the subject's body position at this point, so that their shoulders and torso are not square to the camera.)

Golden Hour. Many weddings/receptions take place in the evening, when the sun is low in the sky. This is actually one of the best times of day to photograph people, because you don't need to worry about overhead light. The light at this time of day is softer and more flattering.

ARTIFICIAL LIGHT

Ambient Light. Ambient light is the light that exists in the area without the photographer doing anything to augment it. Unfortunately, many weddings

STAINED GLASS

Many churches have stained glass windows. These beautiful art pieces project the many colors used in the making of the window. Stained glass also, however, cuts down on the amount of light passing through the window for illumination.

When the light in the church comes from stained glass windows and incandescent illumination from candles and overhead lights, it is a safe bet to set the camera's white balance to incandescent for proper color balance.

If you have an opportunity to take pictures of anyone in front of the stained glass in the church, I would recommend that you use a flash for these images. The flash will allow for normal illumination of your subject without overpowering the light from the window, allowing the viewer to enjoy the rich colors of the glass. Windows create a serious backlighting situation. Working in the automatic exposure mode, be sure to lock your exposure on the subject and not the window. Otherwise, your subject will be severely underexposed.

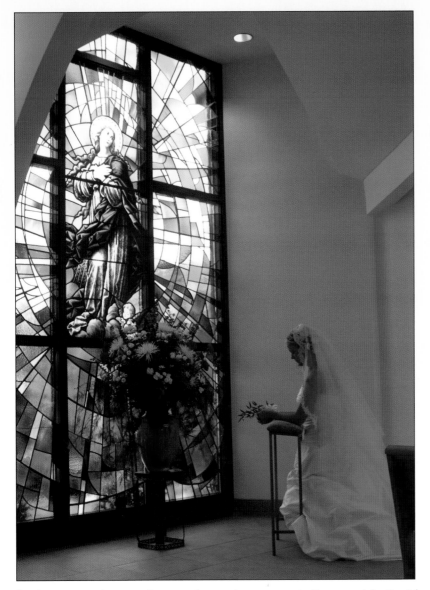

The dramatic window sets the stage for an elegant portrait. Photograph by Patrick Rice.

take place in locations where there is little ambient light. Dimly lit churches and reception halls, for instance, can make it tricky to produce top-quality images.

In these situations, you may want to select a large aperture and higher ISO setting to help keep your shutter speed short enough to freeze any action in the scene (and to reduce blurring from camera movement if you are handholding your camera). Again, knowing in advance the highest ISO setting at which your camera will produce acceptable prints is critical to making a good choice.

Conversely, if you can stabilize your camera by placing it on a tripod, table, or ledge, you might also try taking some shots with a longer shutter speed (try $\frac{1}{30}$ or 1 second). Try a shot of people dancing at the reception, for example. You'll find that the dancers are rendered as whirling blurs while the room and any people who are standing still will be quite sharp. For examples of this, see page 26.

Built-in Flash. The light from on-camera flash is notoriously unflattering—it tends to produce harsh shadows on and around the subject, making these images look anything but natural. When more light is needed, however, flash is necessary. Keep in mind, however, that these units are only effective over short distances. If what you want to see in your photograph is more than fifteen feet away, you may need to try another strategy—like using the night portrait mode.

Night Portrait Mode. When you shoot with flash in large, dimly lit rooms, you may find that your sub-

jects are brightly lit, but the areas around them are almost totally black. Switching to the night portrait mode causes your camera's shutter to remain open a little longer than it otherwise would. This means that your subjects will still be lit by the flash, but the dim details in the background will also have a little added time to register on the image sensor.

Accessory Flash. Alternately, you may be able to use an accessory flash specifically designed by the camera manufacturer to work directly with your particular digital camera brand. While these units may seem intimidating, through-the-lens metering capabilities exist with these dedicated flash units so that the photographer can allow the computer in the camera to determine how much light is necessary for proper exposures in almost any situation. Check your camera's manual (or the manufacturer's web site) to see whether you can use an accessory flash with your camera and, if so, what models are recommended. If you decide you'll want to use this type of light, be sure to purchase your flash well before the wedding and spend some time practicing with it in a variety of settings. This will make you more confident on the day of the wedding.

LEFT—One problem with on-camera flash is that it may not reach the background. As a result, your subjects are lit up like it's broad daylight, but the background looks like a black cave. RIGHT—Accessory flash units tend to do a better job of lighting large spaces, but even these have their limits. Photographs by Patrick Rice.

4. COMPOSITION

Composition is the effective arrangement of all of the visual elements that fall within the frame of the final image. In this chapter, we'll look at some compositional strategies that will help you ensure a stronger, better-crafted image.

In this otherwise rather light scene, the boy's black tuxedo makes him stand out. Photograph by Patrick Rice.

CENTER OF INTEREST

In creating your image, you want to have one and only one primary center of interest. The main subject should be the thing that catches your eye. To accomplish this, you must ensure that the other compositional elements within the four borders of your image lead the viewer's eye back to your subject. They must never direct the viewer's gaze out of the photograph or away from the main subject. The following are two elements to consider.

Contrast. Areas of high contrast attract the viewer's eye and should be evaluated carefully to ensure that they do not draw the viewer's eyes away from the subject. In an overall dark scene, the area of highest contrast is the lightest part of the image. In an overall light scene, the area of highest contrast is the darkest part of the image.

Consider, for example, a picture of a bride in a white dress against a solid background of dark-green trees and foliage. The bride in her light-colored gown will, appropriately, be the area of highest contrast and the part of the image to which your eye is drawn. Now imagine that there is a bright sky area over the treetops—suddenly the bride will compete for attention in the frame. The same thing happens when breaks in the tress allow little bright spots of sky to show through the foliage. Details like these can destroy the impact of an otherwise carefully composed image.

Leading Lines. Leading lines that draw your eye in toward the subject(s) can greatly enhance the composition of an image. Paths, walkways, fence posts, etc.,

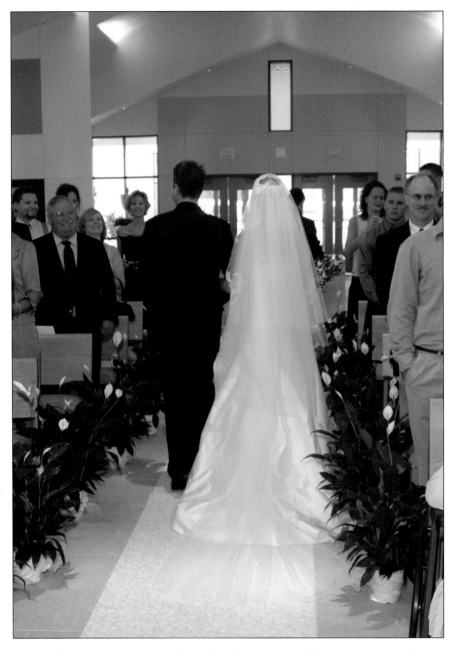

The aisle runner and rows of standing guests serve as leading lines that draw your eyes right to the subjects—the departing bride and groom. Photograph by Patrick Rice.

are leading lines that are often found in successful photographs. Inside churches, the pews lead from both the left and the right to the center of the image where the subject is usually placed. The human eye naturally follows lines toward where they lead. Understanding this and utilizing this technique will result in more effective photographs.

In the Western world, we read from left to right. We subconsciously "read" photographs in the same way. Therefore, leading lines that bring the viewer from the left side of the image over to a main subject on the right can greatly enhance the impact of the photograph.

SUBJECT PLACEMENT
Viewers typically regard more favorably those images where the main subject is positioned off center. This type of composition creates a "flow," a

The human eye naturally follows lines toward where they lead.

natural arrangement of elements that draws your eye through the frame and toward the main subject (never out of the frame or away from the main subject). To create such an image, many photographers employ the Rule of Thirds.

Rule of Thirds. To compose an image according to the Rule of Thirds, imagine that the photograph is dissected by two horizontal and two vertical lines (this should appear much like a tic-tac-toe board). Your main subject should be placed in one of the points where these lines intersect. These points of intersection are referred to as power points because they are natural centers of visual attraction. By placing your subject at one of these power points, your images will be more compositionally pleasing. For close-up portraits, the main subject of your image (and the feature that should be

In most cases, positioning the subject according to the Rule of Thirds is an easy way to ensure a pleasing composition. Photograph by Patrick Rice.

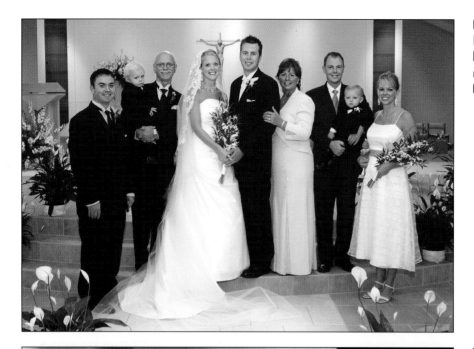

Posed group portraits are usually centered. Here, you can see how centering emphasizes the relative symmetry of the subject. Photograph by Patrick Rice.

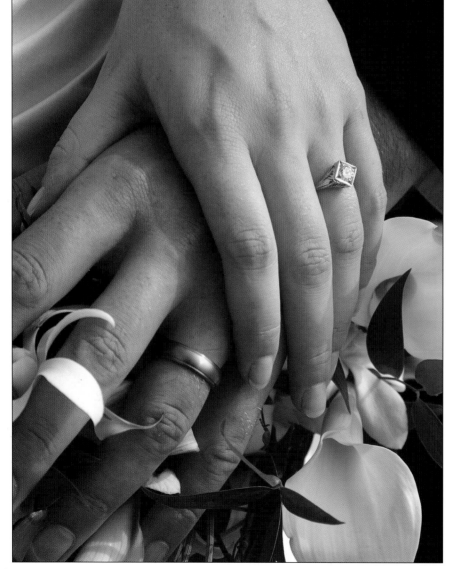

Here, the rings are centered in the frame, but the fingers are posed to create interesting diagonal lines. The flowers add a little extra texture. Photograph by Patrick Rice.

placed according to these rules) is the person's eyes. For portraits that show more of the body, the subject is the face as a whole.

Because we read text from left to right, the strongest power point in the image is generally the one at the lower right. Since the eye rests comfortably here, many photographers place their subjects at this point. Your subject can, however, be successfully placed at any of the intersections.

Centering. Centering your subject is usually considered a mistake. However, centering is appropriate when the subject is symmetrical; this creates a bull's-eye effect that draws the viewer's eyes right into the center of the image and doesn't let them go. Posed group photographs are almost *always* centered. Photographs like the exchange of rings also tend to be centered for maximum impact. Close-up pictures can be centered as well, though they can be produced in many different compositions.

COMMON PROBLEMS IN COMPOSITION

Distracting Elements. In addition to placing the subject of your photo in a powerful position in the frame, you can also improve your compositions by eliminating distracting elements. Distracting elements are anything in a photographic image that draws attention away from the main subject in the photograph.

Things that look unnatural or out of place (e.g., telephone poles, light switches, street signs, etc.) are distracting elements. Objects that are in a dramatically different color can be distracting as well. Bright areas amidst dark tones are common distracting elements and should be eliminated when possible.

As a professional photographer, I am always trying to avoid having objects (buildings, telephone poles, etc.) appear to be growing out of the heads of my subjects. You can alleviate this problem by moving your subject, changing the spot where you are standing, or changing your camera

The strongest power point in the image is generally the one at the lower right.

LEFT—Here, the bright white sky is something of a distraction—it draws your attention away from the bride and groom. If you notice this, see if there's a better location to take the picture. RIGHT—Sometimes distractions are just a part of life. Here, the image would certainly be better without the chair leg. Trying to reposition the boy for another shot, however, would have ruined the moment. Photographs by Patrick Rice.

angle. The easiest way to check the background is to take a photo, then activate the review or playback function on your camera and look at the areas around your subject. See if anything in the background might be distracting, and make changes as necessary. Moving your subject (or yourself) even a few feet to the left or right can eliminate many problems.

Foreground distractions, although not as common, can also happen when you are in a hurry to take your pictures. When shooting over pews, tables, people, etc., do your best *not* to include them in your pictures. This problem is especially common when taking table pictures. If you can safely do so, it is a good idea to temporarily remove overly large centerpieces for these shots. Trying to shoot around them can be difficult, and including them seldom adds anything worthwhile to the shot. Another problem that occurs when taking table pictures is the items on the table in front of the guests. Empty beer bottles and drink glasses aren't items the bride and groom want as a remembrance from their special day!

Foreground distractions can happen when you are in a hurry to take your pictures.

Here, the foreground distractions were minimized by shooting through a gap between the glasses. Photograph by Patrick Rice.

Crooked Horizons. It is important that you maintain straight horizon lines in your images. A crooked horizon is distracting. This problem is especially pronounced in scenes that include the ocean in the background. If the horizon is crooked, it looks like the water is going to pour out of the photograph.

Crooked Vertical Lines. Crooked vertical lines can also be a distraction in your images. These are often caused by not shooting directly toward the vertical subject, but rather shooting from a slight angle (either up or down). Some camera lenses are also more likely than others to distort the vertical lines in an image. Less expensive or inferior wide-angle lenses in particular tend to create crooked verticals.

Dividing Horizontal Lines. Successful images usually do not have dividing horizontal lines that cross directly through the center of the image. It is important to try to place horizontal lines in either the lower third or upper third of the finished print. This technique gives the print better balance and keeps it from having a bisected appearance (i.e., looking as though there are separate upper and lower images). In the compositional Rule of Thirds, we place important subjects in one of the intersecting points of the tic-tac-toe board that you can imagine sits atop every image. Any prominent horizontal lines in the image should also ride along either the top or bottom horizontal line of that tic-tac-toe board.

In addition, you should avoid composing images so that horizontal lines divide or cut through your main subject. Instead, try to place the subject under or considerably above any horizontal line in the image. When shooting, this can be achieved by changing your perspective in relation to

Here the horizon line (and the line of subjects) is placed about one-third of the way up from the bottom of the frame. Photograph by Patrick Rice.

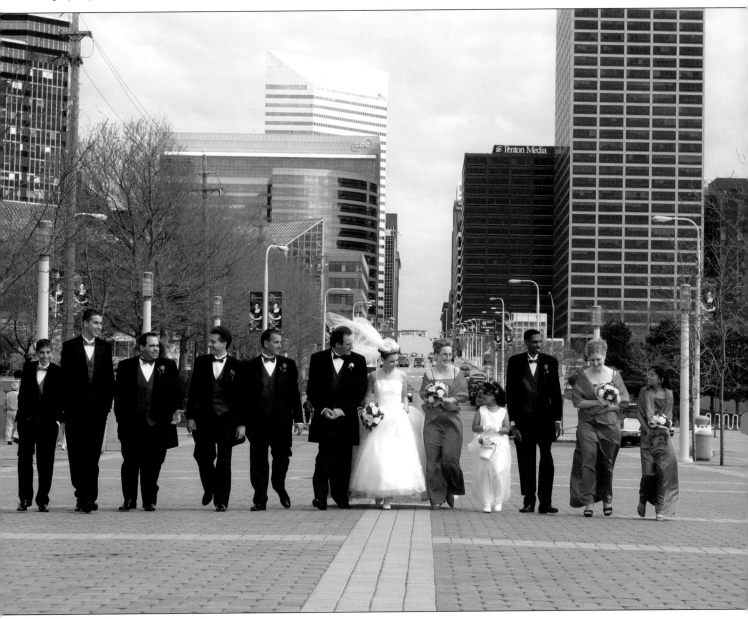

the subject. As you lower your perspective (camera position), you will raise the subject up into the top of the image, far above the horizon line. As you raise your perspective, you will lower the subject toward the bottom of the image, thus composing them beneath the horizon line. Either option gives a more visually pleasing appearance to your photograph.

IMPROVING COMPOSITION AFTER THE SHOOT

In the excitement or stress of the shoot, or just due to the realities of the location or subject, it's inevitable that not every composition will be perfect. Fortunately, digital imaging gives us some recourse.

Cropping. Often, you can improve the image by cutting out any problem elements. Review each image carefully and evaluate whether the composition supports your message about the subject and its relation to the setting. Are there distracting elements that need to be removed? Are there leading lines that draw your eye *away* from the subject? Is there dead space that contributes nothing to the image? You may want to experiment with different ways of cropping out any elements you feel need to be eliminated.

Retouching. Sometimes, distractions in an image can't be eliminated when shooting or even cropped out. While retouching out problems can sometimes be time consuming, it may be worth it to save a particularly

Cropping the original image (left) eliminated some dead space around the bride and groom—as well as the thermostat on the wall! Photographs by Anthony Zimcosky.

When it's not possible to control the background by changing position (or, as often happens, you don't notice a problem until after the shoot), image retouching can help. Here, a distracting light spot in the background of the original image (left) was eliminated for a better composition (right). Photographs by Anthony Zimcosky.

good shot. Bright spots showing through gaps in foliage are easy to eliminate using just about any image-editing software, as are many other simple distractions (like light switches on a wall).

5. POSING

In most photographs, the posing of the subjects is vitally important. Many times, a photographer will have a great subject in a "fabulous location" but will fail to pose them properly. As a result, the image will not be successful (or at least not as successful as it might have been). When you have the opportunity to take posed pictures throughout the wedding day, there are a few tips to help make them the best they can be.

THE HEAD, SHOULDERS, AND BODY

Most professional photographers ensure that their subjects are turned at an angle to the camera. Posing the subject head-on to the camera results in a static image that increases the apparent width of the body. By positioning the subject at an angle to the camera, we create a more flattering and dynamic image.

LEFT—Placing your subject's torso at an angle to the camera creates the most flattering view. Photograph by Patrick Rice. RIGHT—When the subjects' heads are slightly tilted, a more pleasing pose is achieved. Photograph by Anthony Zimcosky.

HEAD TILT

Tilting the subject's head very slightly, no matter the pose, creates a diagonal line from one eye to the other. Diagonal lines are always more interesting than horizontal ones, so this simple change can enhance every portrait. Traditionally, the female subject's head is tipped slightly toward the shoulder nearest the camera, and the male subject's head is tipped slightly toward the far shoulder. However, this is not a hard-and-fast rule. The overall appearance of the subject may dictate a different approach.

CHIN HEIGHT

Be sure that your client's chin is positioned neither too low or too high, as one extreme can create an impression of haughtiness and the other, a lack of self-esteem.

HANDS

It is best to present the side of the hand (rather than the palm or back of the hand) to the camera. This affords a more natural, flowing line. Additionally, be sure that the client's fingers are slightly separated. Otherwise, the hand may look like a blob. Ideally, the wrists should be very slightly bent

If you don't want to worry about posing the hands, hide them behind a bouquet or (for the guys) in pockets. Photograph by Patrick Rice.

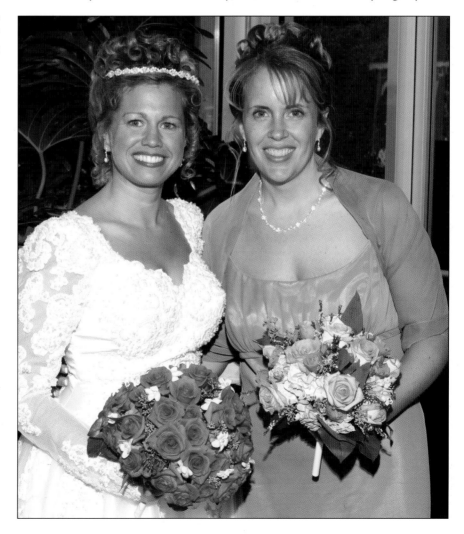

(not stiff) to ensure a relaxed look. Though rules can often be broken to good effect, it's traditionally thought that a man's hands should exhibit strength in the portrait, and a woman's hands should appear graceful.

FEET

To avoid making the subject's feet look short and wide, ensure that they are not pointed directly into the lens. For standing poses, the subject should avoid evenly distributing their weight on both feet. With one foot slightly behind the other, their weight resting primarily on the back foot, and the knee of their front leg slightly bent, the subject will be more comfortable.

THREE-QUARTER AND FULL-LENGTH POSES

Three-Quarter Poses. The three-quarter view shows the subject from their head to somewhere below the waist. It is best that the bottom of the frame falls at mid-thigh or mid-calf. Composing the image so that the frame cuts through the knee (or any other joint) tends to create an unsettling impression.

In standing poses, avoid posing the subject with their arms simply hanging at their sides. A man may be effectively posed with his arms folded across his chest, with the hands in a side view as he gently grasps his biceps. There should be a small space between his arms and chest, as this provides

LEFT—In a three-quarter view, you see the subject down to somewhere below the waist. **RIGHT**—Don't let your subjects' arms just hang there—give them something to do. In this light-hearted group portrait, the guys are either leaning on one knee or holding their coats over their shoulders. The bride has her arm around her new husband's shoulders, and he has his arm around her waist. Photographs by Patrick Rice.

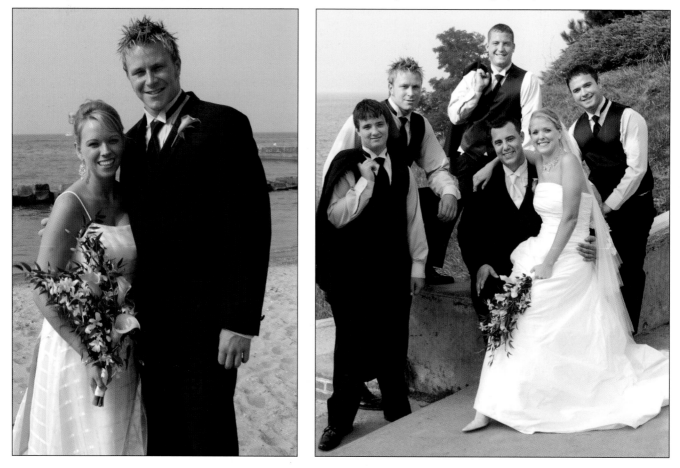

a slightly slimmer, more flattering presentation. A woman can be successfully posed with one hand on her hip. The other arm should be slightly bent, with the wrist bent and a side view of the hand presented to the camera.

If the subject is seated, a cross-legged pose can be effective. Leave a slight space between the back of the leg and the chair to provide the most slimming, flattering view. When posing a seated female client, it's a good idea to have the calf of the leg closest to the camera tucked slightly behind the back leg. This reduces the apparent size of the legs.

Full-Length Poses. A full-length portrait, as the name implies, affords a complete, head-to-toe view of the subject. As described above, each of the areas of the body should be posed to present a flattering view of the subject. Throughout this book you will find a variety of images that feature full-length poses. Study these and use them to inspire your own work.

GROUP PORTRAITS
All of the rules outlined in this chapter apply to posing the individuals in a group portrait. The bottom line is, each subject in the group portrait should look his best, and each pose should stand on its own to produce a compositionally sound, attractive image.

HEAD HEIGHTS
When posing two or more people, you should seek to stagger the head heights in the portrait. For instance, a tall man might be seated on a chair with his wife standing by his side. By slightly staggering the head heights, you can ensure that the viewer's eyes will move easily from one subject's face to the next, giving the portrait a dynamic feel.

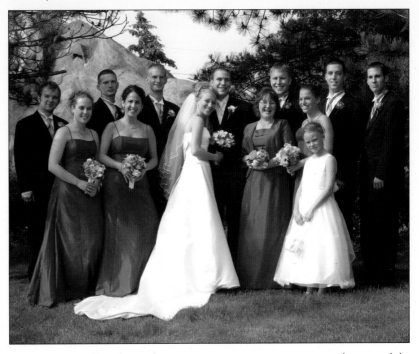

Varying the head heights makes a more interesting group image. Photograph by Anthony Zimcosky.

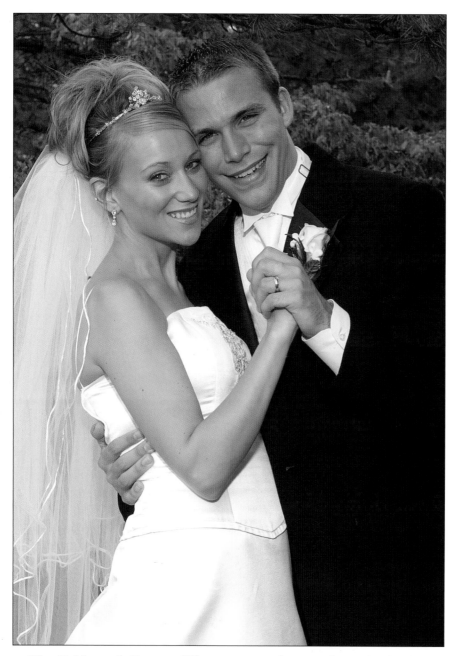

LEFT—Here, the couple almost look like they could be dancing. For a simple variation, you could have them drop their hands. Photograph by Anthony Zimcosky.
ABOVE—The basic dance and prom poses aren't just for male/female couples, they work for just about any group of two people—especially if you want to show a close relationship. Photographs by Patrick Rice.

The Bride and Groom. When you are photographing the bride and groom (or another married couple), turn the couple toward each other rather than placing them shoulder-to-shoulder. I refer to this as the dance pose. Just imagine what a couple looks like when they are dancing—their back arms are around each other's bodies and their front arms are extended while holding hands. To achieve the dance pose, simply have them lower their front arms or drop their front arms to their sides. This creates a more professional-looking portrait of any couple.

For a little variety in your pictures of the bride and groom, you can pose them both at a 45-degree angle to the camera, with the bride standing with her back to the groom. I refer to this as the prom pose. (If you can remember your prom, you will remember this classic pose!) The groom should place his front hand on the bride's waist and the bride should be holding

her bouquet. If you are posing two couples together, you can pose each couple in opposite prom poses facing each other for a balanced look.

Bigger Groups. If you are photographing a group of people with the bride and groom, start with the newlyweds in the dance pose (see above) and position them in the center of the picture with an even number of people on either side of them. Turn each of the people in this group picture in toward the bride and groom. In addition to flattering the people in the photo, this pose will help to condense the group, because people take up less space when turned at an angle than they would if standing shoulder to shoulder.

With the bride and groom in the dance pose, the wedding party is placed around them. Photograph by Anthony Zimcosky.

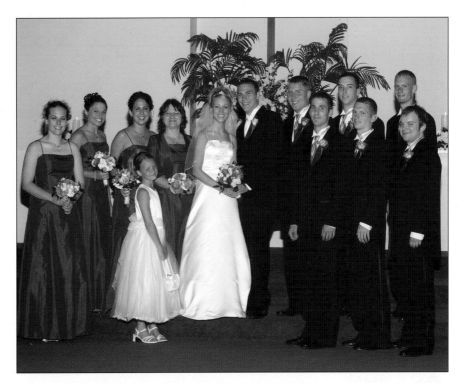

Here, the bride and groom are seated in the center and the wedding party is gathered around them in standing and seated poses. Photograph by Anthony Zimcosky.

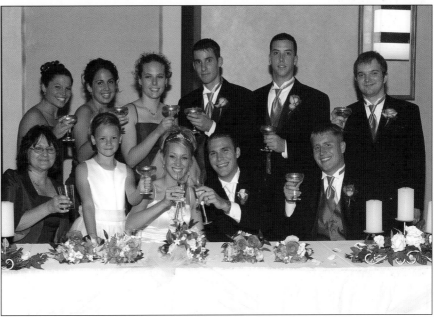

As groups of people in a picture get larger, the tendency is to pose them in rows—but this is not always the best idea. Instead, consider using chairs to sit some of the people down in front and have the others stand behind them. If there are children in the group picture, you could sit them on the floor in front of the chairs. I find the best way to pose the children is to have them kneel down and then sit back on their legs. By condensing your group pictures in this manner, you will make the best-possible photos for the bride and groom.

When posing three or more subjects, you should also seek to create a uniform distance between subjects. Leaving more space between one grouping than another will detract from the cohesive feeling you are seeking to create.

Here the guys are posed in a row with the groom in the center. Notice how the men on either side of the groom are all turned in toward the center of the photograph. This helps draw the viewer's eye back to the groom. Photograph by Anthony Zimcosky.

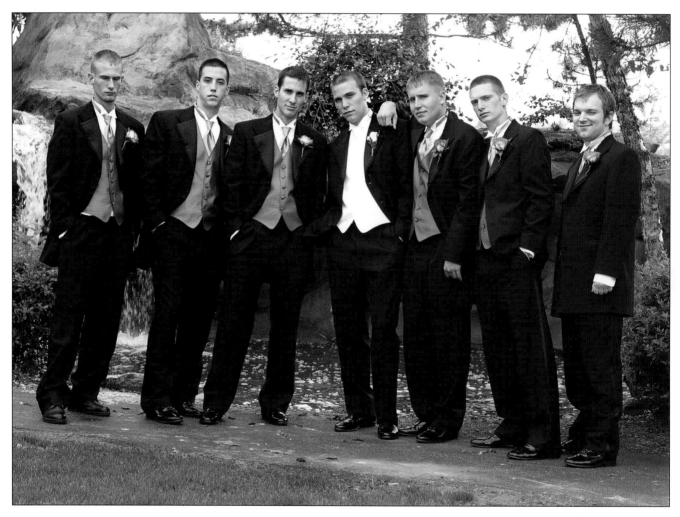

6. THE WEDDING DAY

Keep an eye on the professional photographer and avoid shooting the same images or obstructing his or her coverage of the event. Photograph by Patrick Rice.

The big day has finally arrived! You've practiced using your camera in a variety of situations like those you might encounter when taking pictures at the wedding. You've packed plenty of memory cards and spare batteries—you're totally prepared. Once things get going, though, they'll be fast and furious . . . so here are a few photo opportunities to keep an eye on.

BE AWARE OF THE PROFESSIONAL

The bride and groom will have devoted a significant part of their wedding budget to hiring their professional photographer. Therefore, it is critical that you are conscious throughout the day not to interfere with his or her work.

Keep an eye on where he or she is shooting and look for other moments to capture with your camera. Or, if you must shoot the same event, do not attempt to take your pictures from the same *places* that the professional photographer takes his/her pictures. This ensures that your images will be a unique and welcome addition to the mementos of the day. (Remember, you are not trying to replace the professional photographer, you are trying to create pictures to *supplement* what the professional will provide.) Also, you won't risk making the pro miss an important shot (something the couple *won't* appreciate!).

BRIDE AND GROOM GETTING READY

Both the bride and groom have to get ready *somewhere* for their wedding day. With some couples, it may be at the church. Others will get ready at home or in a hotel room. If you have access to these areas, try to get pictures of the rooms they are using to get dressed. The clutter and chaos make nice candid pictures to remember this hectic time. Detail photographs are always a good idea. A picture of a makeup case, the dress-

Women love their shoes and select them very carefully, so a photo like this is sure to bring a smile to the bride's face. Photograph by Patrick Rice.

es or tuxedos in their bags from the store, shoes lying around on the floor—all of these make interesting pictures.

If the bride and groom are getting ready at a hotel, take a picture of the outside of their hotel room showing the room number. Many couples have a bottle or two of champagne in their rooms for the bridal party. Take a picture of the bottle and glasses. Being small rooms, hotels are usually cluttered with lots of clothing, food, and people. Documenting all of these will make it easier for the bride and groom to look back on this often overlooked segment of the day.

When the bride and groom get ready at their parents' homes, you have some unique photographic opportunities. It is not uncommon for the groom to have flowers delivered to the bride at the house. Take a picture of both the flowers and note enclosed to his future bride. Around the home,

Many couples have champagne in their rooms for the bridal party.

CANDID PHOTOGRAPHY

Candids cannot be planned, but they can be anticipated. For example, as the bridesmaids, relatives, and friends arrive at the house, it is highly likely that each will give the bride a warm greeting. These genuine hugs and kisses make great candid pictures. If the bride and/or bridesmaids are not completely ready, you may also have the opportunity to get some candids of them finishing up with their hair, makeup, etc. Here, women photographers have a distinct advantage in that they can usually be in the actual dressing area and have a chance to get some tasteful candids of the women finishing up the dressing process.

you may find little mementos that belong to the couple. These items highlight important moments in their lives to this point. I'll even take pictures of pictures that are framed and displayed on a table or fireplace mantel. If the parents have a wedding album from their own wedding day, it makes a nice picture to show the parents sharing the album with their child and reminiscing about their own wedding day.

Pets are part of the family, too. If you get to photograph the bride or groom at home, a special portrait with the family pet can make a great keepsake. Photograph by Patrick Rice.

Keep an eye out for special items and make sure to capture shots of these little details. Photograph by Travis Hill.

ABOVE—Flowers are a big part of most weddings, so don't forget to document them. Photograph by Patrick Rice. LEFT—Often, the bride presents each of her attendants with a gift before the wedding. Photograph by Anthony Zimcosky.

As the florist arrives at the house, you can take pictures of her presenting the flowers to the bride and her bridesmaids as well as pinning on boutonnières and corsages. It is also nice to take pictures of the florist; she is mostly overlooked in photos but plays a big part in the wedding day.

Keep in mind, not all professional photographers will go to the location where the bride is getting ready. Therefore, this is a case where you, as a friend of the bride and groom, can provide the couple with pictures that would otherwise be missed.

If the couple's photographer *will* be photographing the bride's preparations, consider going to where the groom is getting ready to photograph him, the groomsmen, and his family. Few professional photographers will go to *both* the bride's house and the groom's house prior to the wedding. Your pictures from the groom's perspective can provide a wonderful balance to the numerous images the professional photographer will take of the bride before the wedding.

AT THE CHURCH

At the church, you have another chance to get nice candids of relatives and guests, this time greeting the parents of the bride and groom. Weddings are an excuse to gather the family together and to celebrate the joining of two families—both good reasons to get great pictures of the guests.

THE PROCESSION

Candid images during the ceremony are wonderful pictures the bride and groom will appreciate. Since you are not the hired photographer, I do not recommend that you move around during the ceremony. Scout out a good seat (on the aisle if possible) before the service begins and take all your photographs from there. If you are certain you won't be in the way of the pro-

As the groom awaits his bride, you can almost feel the tension in the air. Photograph by Patrick Rice.

Grab a good seat and take a close horizontal image of the bride and her father. This will complement the full-length vertical shot the professional photographer will undoubtedly create. Photograph by Patrick Rice.

fessional photographer, you could venture into the middle of the aisle directly across from your seat to get a couple of quick pictures. Be aware, however, that the professional may be behind you or up in the balcony. Ruining the professional photographer's image while trying to take your picture will not make the bride and groom happy.

Before the bride starts down the aisle, try to get a picture of the groom as he awaits his new bride at the front of the church.

Then, as the bride and her father come up the aisle, position yourself at the end of your pew so that you have a clear view without having to step into the aisle—possibly ruining the photo being taken by the professional. As she begins her procession, take pictures of the expressions on the faces of the guests sitting across from you. When the bride approaches, get a close horizontal picture of the bride and her father. The professional photographer will take a full-length vertical photograph of them, so why create the same thing? Making your pictures different and unusual will provide more benefit for the couple.

Take pictures of the expressions on the faces of the guests sitting across from you.

THE CEREMONY

During the wedding ceremony itself, try to pay attention to what the professional photographer is doing. Not every professional takes the same images. If you see something of importance going on that the pro isn't shooting, by all means—get a picture.

For instance, sometimes guests give readings during the wedding. As a professional, I can tell you that these images are not a big seller. As a result, some photographers may just skip those shots. The readers are always important to the bride and groom, however, and they will appreciate having your pictures to remember their role in the wedding.

TOP LEFT AND RIGHT—Because images of the readers and performers at a wedding are not big sellers, many professionals skip them. However, the bride and groom will appreciate a good shot of these people. ABOVE AND RIGHT—During the ceremony, professional photographers are usually focused on the couple. You can capture the emotions of the onlookers. Photographs by Patrick Rice.

ABOVE—Knowing what the couple has planned at the ceremony will help you anticipate key moments. Photograph by Anthony Zimcosky. RIGHT—At the end of the ceremony, there will be lots of smiles. Capturing this from a different angle than the professional can give the couple more variety in their images. Photograph by Patrick Rice.

Also, observe the guests' reactions to everything that is going on. Wedding ceremonies are emotional events. Recording these emotions is often difficult for the professional photographer who needs to concentrate on the important symbolic moments that happen. Here is where you can shine. It will be easy for you to focus on the guests sitting across the aisle. As they smile, laugh, and cry, take pictures to document these feelings.

There are also certain key elements to every wedding ceremony—whether it's lighting a unity candle, jumping the broom, or some other tradition. It is a good idea to know what kind of wedding the bride and groom are having. If you are not familiar with a particular wedding service, you should do some research prior to the wedding so that you know what to look for and what to take pictures of through the service.

Additionally, keep in mind that many churches and synagogues do not permit flash photography. Even if flash is permitted, a constant barrage of flashes is distracting to both the guests and the couple. The wedding ceremony is a serious, spiritual occasion, and everyone should be allowed to focus on it with minimal interruption.

Also, disabling or turning off the flash forces your camera to choose a large lens opening. This produces a shallow depth of field (see chapter 2).

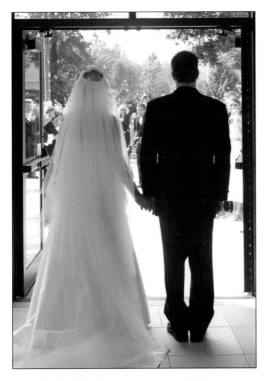

This can be a great asset in composing powerful images, since it helps the viewer of your picture concentrate only on what is still sharp. People in the background will nicely blur out of focus and be less distracting.

EXIT SHOTS

After the ceremony, all professional photographers will take pictures of the bride and groom exiting the church or synagogue. However, not every professional photographer will get a picture of the couple getting into their car or limousine. If you are a close friend of the bride and groom, you could even arrange to hop into the limousine to take pictures of the couple and their bridal party from inside the car. You could even ride with them to the reception site (or the site they've chosen for location photos between the ceremony and reception) and get some great candid pictures during the ride.

The bride and groom leaving the church to the cheers of their friends and family is one of the big moments at many weddings. Photographs by Patrick Rice.

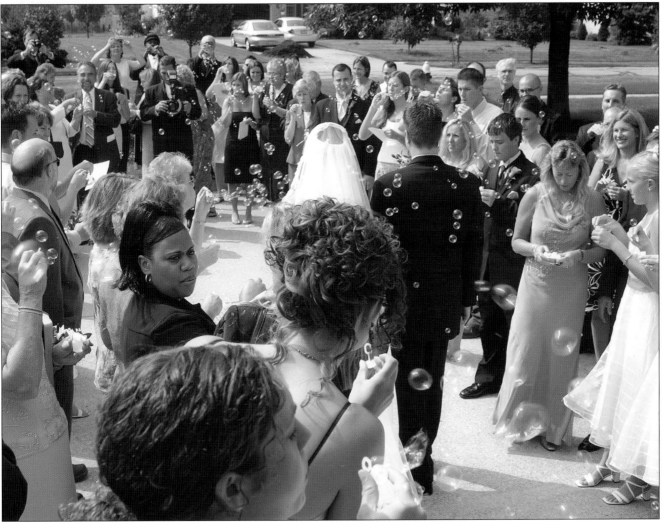

THE RECEPTION

When photographing the reception, the natural tendency is to turn on the camera's flash or just have the flash fire automatically. However, there are times when disabling or turning off the flash can add to the artistry of a picture.

Detail Pictures and Table Shots. If you set your camera to its highest ISO setting, you can begin taking pictures at the reception without the use of flash. Remember that, at most evening wedding receptions, the lights are turned up before dinner and possibly during dinner. After dinner, however, the lights are generally turned down to provide a more romantic mood. This means your best opportunities to take non-flash photographs happen early. Therefore, you should take all of your detail pictures and table shots at this time.

As mentioned earlier, detail pictures are always a good idea before the wedding, and they are a good idea at the wedding reception as well. Pictures of the gift table, placecards, guest book, card box, cake top, table centerpieces, favors, decorations, and anything else that the bride and groom took the time to get for their reception will all be appreciated.

A table shot is a posed photograph of the guests that are sitting at a particular table. Not all professional photographers take these at the reception, so it's a great thing for you to do. The best way to compose a table shot is to ask half of the people at a table to stand behind the half that remain seated. For example, with a table of eight guests, ask the four guests closest to where you want to take the picture from to stand behind the seated guests opposite the table from you. It is helpful to have the four guests that remained seated to move their chairs as close together as possible to tighten up the grouping. A picture of each table will certainly be a memorable keepsake for the bride and groom.

After dinner, the lights are generally turned down to provide a more romantic mood.

The gift table is a good shot to take before the lights drop. Photograph by Patrick Rice.

Many wedding receptions feature toasts given by the best man and maid of honor. These are the people the bride and groom have selected to stand with them on this important day, so they will definitely appreciate pictures. Photographs by Patrick Rice.

Dance Floor. Once the lights are turned down, pay close attention to what illumination is left for the reception. Sometimes the band or DJ will bring in lighting systems to illuminate the dance floor and the guests dancing. The lighting effects can be quite dramatic, and using your flash will destroy the effect in your pictures. The projected patterns and dancing lights look great during the dancing, and the bride and groom will love pictures that help them remember it. Ironically, very few professional wedding photographers take the time to record these special moments in the most flattering manner.

When trying to utilize the dance-floor lighting, there are two approaches you can take. First, you can take your pictures from where the lights are, recording the colors and patterns as they fall on the guests dancing. This is the more traditional and easier way of taking these types of pictures. The lighting may be bright enough to keep all of your pictures in sharp focus even without a flash.

The other approach is to stand opposite the dance-floor lighting and have those lights illuminate your subjects from behind. Your exposures will be considerably longer and your photographs probably won't be in sharp focus, but the results can be stunning. As a professional, I routinely take photographs of people dancing at the reception in this manner. I select the automatic mode and allow my camera to choose the aperture and shutter

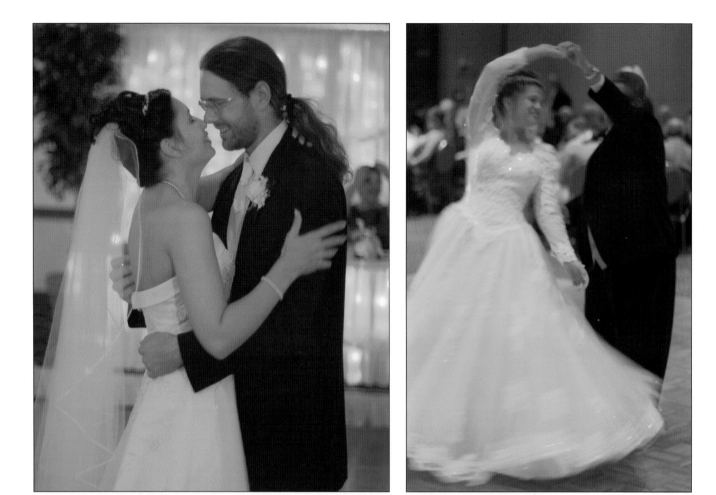

ABOVE—Without the use of a flash, a long exposure captures the color of the light and the motion of the couple. Photographs by Travis Hill (left) and Patrick Rice (right). LEFT—Don't forget to document the music—especially if the couple has hired a band. Photographs by Travis Hill.

speed. Since there is very little light available, the aperture is at its maximum setting and the shutter speed may be very slow. I try to hold the camera as still as possible and let the guests gently blur in my images. This effect gives the viewer of the image a feeling of motion and a sense of the party. My clients love this look and usually include these images in their wedding album. Having said that, I must point out that few of my colleagues employ this technique. If you provide pictures like this of your friends, they will certainly be impressed by your technical prowess. They may even like your pictures more than the professional's for these dancing images.

End of the Reception. Not all professional photographers will be at the wedding reception until the end of the night. However, today's brides and grooms rarely leave their wedding until the last note has been played. As a guest who is

The wedding cake is something the bride and groom select carefully. You should have plenty of time during the reception to document it. Then, try to get a photograph of the bride and groom cutting it. Photographs by Travis Hill.

enjoying the wedding and the company of your friends and family, you have the opportunity to record the entire event and to capture a "real" exit image—probably at midnight or later. It is very possible that the bride and groom will prefer this picture to the one the professional photographer may have staged hours earlier. Many of today's couples want realism in their pictures and don't always expect to look perfect in each photo.

Be prepared for some silliness as the couple feeds each other their first bites of the cake. Photographs by Anthony Zimcosky.

7. ENHANCING YOUR IMAGES

More often than not,
your image won't
be exactly the size
you want for your print.

Photographers the world over are familiar with and use Adobe Photoshop on a daily basis—and if you have access to this software, it's a wonderful tool for refining your images. For most nonprofessionals, however, Photoshop is prohibitively expensive and overly complex. Enter Adobe Photoshop Elements—Photoshop's little brother! It has most of the most popular features of Photoshop at a fraction of the price—around $100. This mighty little program is easier to understand than Photoshop and still offers more features than most users will ever need to correct and enhance their digital pictures.

The Photoshop Elements techniques in this chapter address some of the most commonly needed adjustments and enhancements to wedding images. They are adapted from *Beginner's Guide to Adobe Photoshop Elements* by Michelle Perkins (Amherst Media, 2004). If you want to learn more about making your images look their best with Adobe Photoshop Elements, you may wish to consult this book.

CHANGING IMAGE SIZE

More often than not, your image won't be exactly the size you want for your print. In these cases, you'll need to change the image size. If your image will be used in several ways, you may need to resize a few times to get the assortment of sizes you need. Whenever you resize, remember to work from your largest needed file to your smallest.

Going to Image>Resize>Image Size lets you enter a height, width, and resolution for your image. At the bottom of the Image Size window, you'll see two very important boxes. The first is the Constrain Proportions box. When this is checked, the original relationship between the height and width of the image will be retained. Unless you intend to distort your photograph, you should always keep this box checked.

The Resample Image box lets you tell Elements whether you want it to add or subtract from the total number of pixels in your image. If this box is *not* checked, increasing the height and width of your image will decrease the resolution (the existing pixels will be spread out over a greater area). If this box *is* checked, increasing the height and width of your image will not change the resolution (more pixels will be created to fill the greater area).

CROPPING

The Crop tool is used to remove extraneous areas from the edges of a photo. This is a great way to improve the look of photographs you didn't have time to frame carefully or ones that you just didn't compose as well as you might have liked.

To crop an image, choose the Crop tool from the Tool bar. Click and drag over the area of your image that you want to keep, then release your mouse button. You don't have to be incredibly precise. At each corner of the crop indicator (the dotted line) you will see small boxes. These are handles that you can click on and drag to reshape or reposition the box. (As you get near the edges of the photo, these handles tend to "stick" to the edges. To prevent this, click on the handle you want to drag, then press and hold the Control key while moving the handle.) When the cropped area looks right, hit Enter.

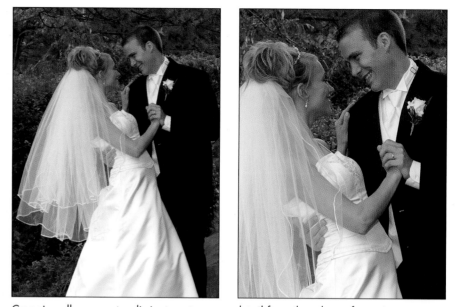

Cropping allows you to eliminate extraneous detail from the edges of your images or to present your images in different ways for added variety. Photograph by Anthony Zimcosky.

The Crop tool can also be used very effectively to straighten a crooked image. Simply click and drag over the image with the Crop tool, then position your mouse over one of the corner handles until the cursor's arrow icon turns into a bent arrow icon. Once you see this, click and drag to rotate the crop indicator as needed. Doing this may cause the edges of the box that indicates the crop area to go outside the edges of the image. If this happens, simply click and drag on each one to reposition them within the edges of the frame.

In the Options bar at the top of the screen you can set the final size of the cropped image. This is helpful if, for instance, you specifically want to create a 4x6-inch print to frame. Simply enter the desired height, width, and resolution needed before cropping, then click and drag over the image to select just the area you want in your print. The Crop tool will automatically constrain itself to the desired proportions.

CROPPING AND RESOLUTION

Cropping reduces the total number of pixels in an image. If you are working with an image from a digital camera, the total number of pixels in your image is fixed, so you'll need to determine the final resolution and image size you need for your intended output and not crop the image to a smaller size than that.

SHARPENING

If your image looks pretty much okay to the naked eye, but a little fuzziness is apparent when you really get critical, sharpening may do the trick.

To sharpen an image, go to Filter>Sharpen and select the tool you want to use. As noted below, some filters run automatically, while others require you to adjust their settings.

The Sharpen filter automatically applies itself to every pixel in the image or selection. It works by enhancing the contrast between adjoining pixels,

creating the appearance of sharper focus. The Sharpen More filter does the same thing, but with more intensity.

The Sharpen Edges filter seeks out the edges of objects and enhances those areas to create the illusion of increased sharpness. Elements identifies edges by looking for differences between adjacent pixels.

Unsharp Mask is the most powerful sharpening filter in Elements. To begin, go to Filter>Sharpen>Unsharp Mask. This will bring up a dialog box in which you can adjust the Amount (how much sharpening occurs), the Radius (how far from each pixel the effect is applied), and the Threshold (how similar in value the pixels must be to be sharpened). To start, try setting the Amount to 150 percent, the Radius to 2 pixels, and the Threshold to 10 levels. Watch the preview and fine-tune these settings until you like the results.

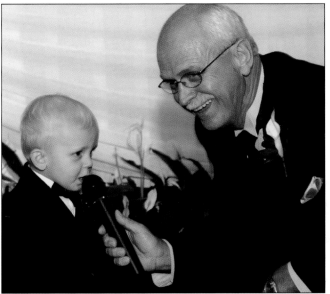 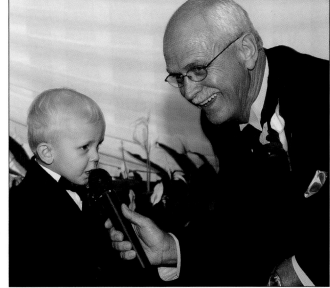

Inevitably, some otherwise good shots won't be quite as sharply focused as you'd like (left). When this occurs, the sharpening filters can really help (right). Photograph by Patrick Rice.

Watch out for oversharpening. If you're not sure you've sharpened an image correctly, go to Edit>Undo and compare the new version to the original. If the new one was better, use Edit>Redo to return to it.

Elements also has a Sharpen tool. This is used to "paint on" sharpness in selected areas and works pretty much like the other painting tools. The Select field in the Options bar is used to set the intensity of the effect.

REMOVING BLEMISHES

Professional image retouching can make a portrait subject look like a million bucks. Now the same tools pros use are at your fingertips, so you never have to live with blemishes and other little problems.

The Clone Stamp tool works just like a rubber stamp, but the "ink" for the stamp is data from one good area of your image that you "stamp" over a problem area of your image. Using this tool definitely takes some practice, but once you master it, you'll probably find you use it on just about every image.

To begin, choose the Clone Stamp tool from the Tool bar. Then, set the brush size in the Options bar (the size you choose will depend on the area available to sample from and the area you want to cover). Move your mouse over the area that you want to clone, then hold down the Opt/Alt key and click. Next, move your mouse over the area where you want the cloned data to appear and click (or click and drag). As with the other painting tools, you can also adjust the mode and opacity of the Clone Stamp tool in the Options bar. Don't forget to use the Zoom tool to enlarge your view for precise work.

On a hot day, shiny spots can appear on faces (left). These can be easily removed using the Clone Stamp tool (right). Photograph by Patrick Rice.

ELIMINATING RED-EYE

Red-eye is just a fact of the anatomy of our eyes, but that doesn't mean we have to live with it in our images. Elements makes it easy to remove the problem and create a much more pleasant look. For this correction, it will be very helpful to zoom in tightly on the eyes.

To use the Red Eye Brush, choose it from the Tool bar, then select the brush settings you want. Click on Default Colors to reset the Current Color to red and the Replacement Color to black. Then, make sure the Sampling is set to First Click. Position your mouse over a red area of the eye and click (or click and drag) to replace the red with a dull gray. If all the red isn't replaced, try setting the Tolerance slider higher (the default 30-percent setting will work for almost every image, though).

To select a different Replacement Color to more accurately match the color of the subject's eyes, click on the Replacement Color swatch and choose a new color from the Color Picker.

CONVERTING TO BLACK & WHITE

Unlike film shooters, digital photographers do not have to decide whether an image should be color or black & white at the time of capture. The photographer can now make these decisions after the shoot with no discernable loss in quality of the final photograph. This provides a tremendous advantage to photographers in any field of interest. Although some cameras have a black & white setting, I would strongly recommend not using that setting and capturing the image in color. In this manner, you have not limited the possible applications and modifications of the image like you would if just black and white information was recorded. There are numerous ways of converting a color digital file to black & white.

Converting a color image (left) to black & white (right) takes just a second in Adobe Photoshop Elements. Photograph by Patrick Rice.

To convert a color image to black & white in Adobe Photoshop Elements, just go to Enhance>Adjust Color>Remove Color. For great control over the conversion, you may wish to use one of the many Photoshop plug-in filters that are now commercially available. (*Note:* Any plug-in filter that works with Adobe Photoshop will also work with Adobe Photoshop Elements.) One of my personal favorites is from Nik Multimedia.

HANDCOLORING

Handcoloring photos is traditionally accomplished with a variety of artistic media—oil paints, pencils, etc. With Elements, you can create this classic look much more easily!

Method 1. This technique gives you total control over the colors you add and where you add them.

First, open an image. If it's a color image, go to Enhance>Adjust Color>Remove Color to create a black & white image. If it's a black & white image, go on to the next step. Next, create a new layer and set it to the Color mode.

Double click on the foreground color swatch to activate the Color Picker. Select the color you want and hit OK to select it as the new foreground color. This is the color your painting tools will apply. You may switch it as often as you like.

With your color selected, return to the new layer you created in your image. Click on this layer in the Layers palette to activate it, and make sure that it is set to the Color mode.

PLUG-INS

A plug-in is a small program, designed to perform a very specific function, that runs within Photoshop or Adobe Photoshop Elements. These programs can be used to add functionality to the application.

Select the Brush tool and whatever size/hardness brush you like, and begin painting. Because you have set the layer mode to color, the color you apply will allow the detail of the underlying photo to show through.

If you're a little sloppy, use the Eraser tool (set to 100 percent in the Options bar) to remove the color from anywhere you didn't mean to put it. Using the Zoom tool to move in tight on these areas will help you work as precisely as possible. If you want to add more than one color, you may wish to use more than one layer, all set to the Color mode.

When you've completed the "handcoloring," your image may be either completely or partially colored. With everything done, you can flatten the image and save it as you like.

A color image (left) can be elegantly presented as a handcolored image (right)—and the process takes just minutes. Photograph by Patrick Rice.

Method 2. Here's a quick way to add a handcolored look in seconds—or, with a little refinement, to avoid having to select colors to handcolor with. This technique works only if you are starting with a color image.

Begin by duplicating the background layer (by dragging it onto the duplication icon at the bottom of the Layers palette).

Next, remove the color from the background copy by going to Enhance>Adjust Color>Remove Color. The image will turn black & white—but by reducing the opacity of the new layer you can allow the colors from the underlying photo to show through as much or as little as you like. Try setting the layer opacity to 80 percent for a subtly colored image.

To create the look of a more traditional black & white handcolored image, set the opacity of the desaturated layer to 100 percent and use the Eraser tool to reveal the underlying photo. Adjust the Eraser's opacity to allow as much color to show through as you like.

For a very soft look, set the opacity of the desaturated layer to about 90 percent (just enough to let colors show through faintly) and use the Eraser tool (set to about 50 percent) to erase areas where you want an accent of stronger color to appear.

FILTER EFFECTS

A filter is a specialized piece of software that runs within Elements and is used to apply a specific effect to an image. Many filters are packaged with Elements itself, and other filters (from Adobe and other companies) are also available to meet specialized needs.

You can apply filters using the Filters palette from the Palette Well. After opening this palette, select All from the pull-down menu at the top to see all of the available filters and a thumbnail preview of the effect of each. When you see one you like, click and drag the thumbnail onto your image to apply the filter. Depending on the filter, this may also open a dialog box in which you can customize the filter's settings.

Here's a quick way to add a handcolored look in seconds . . .

You can also apply filters by going to the Filter pull-down menu at the top of the screen. Pulling this down will reveal several submenu categories that contain the individual filters. Select any filter to apply it. Some will apply immediately, some will open a dialog box in which you can customize the settings.

The filters are arranged by groups. One of the most useful groups is called Artistic. The filters in this group are designed to imitate the effects of traditional artistic media, making your photograph look like a sketch, watercolor, or other piece of artwork. Experiment with these filters and their settings as much as you like—you can always use the Edit>Undo command to reverse the effect if you decide you don't like it.

Working from a good photograph (top left), there's no end to the interesting and appealing looks you can create by simply applying the filters in Adobe Photoshop Elements. Photograph by Patrick Rice.

8. PRINTING AND SHARING IMAGES

When digital cameras first became popular, most color labs and stores that processed film were not equipped to make images from digital files. At that time, making prints at home on your personal inkjet printer was virtually the only option available. Today, we have more choices.

LAB PRINTS

It is no longer necessary to make your own prints from your digital camera in order to have good quality pictures. Color labs across the country can now accommodate all digital photographers, and it is easy and inexpensive to get commercially produced photographs. Most chain stores and online photo labs have installed virtually the same processing equipment and the same paper that professional color labs use: Fuji Frontier printers. These operations can now produce a 4x6-inch print for less than twenty cents—much less than it would cost you to print the same image at home on your inkjet! That said, why would you want to spend the time or money to print pictures yourself when you can receive better quality pictures at a lower price?

It is no longer necessary to make your own prints from your digital camera.

FRAMING

Traditional picture frames have always been a popular way of displaying wedding day photographs. In recent years, there has been a trend toward framing smaller images. This is ideal for the friend who wants to provide the bride and groom with a nice wedding keepsake. There are literally thousands of choices in frames for photographs 8x10 inches or smaller. In fact, many of the most creative frames (some with wedding themes) are for these smaller prints.

Collage frames are also becoming very popular with many wedding couples. A collage frame is a multiple-opening frame that holds several prints. Most collage frames hold smaller images of various sizes. To assemble a collage frame, you will have to make custom-sized prints to fit the openings (or cut the normal sized prints to fit the openings). A big advantage of a collage is that it can include several of your favorite wedding pictures in one assembled unit for easy display or mounting.

At scrapbooking supply centers you can purchase stickers to outfit your images with some clever comments.

SCRAPBOOKING

Over the last ten years, scrapbooking has become a popular hobby with many photo enthusiasts. There are numerous books available as well as tutorials on the Internet to help you to create a scrapbook from your friend's wedding day memories. The following steps will help you get started:

1. Sort your photos into themes. In this case, choose sections of the wedding day to work on. If you have the wedding invitation, you may want to place it on the album cover or first page.
2. Select two or three colors of acid-free paper or cardstock to use as the base pages of your scrapbook.
3. Pick one photo to be the main focus of each page.
4. Enlarge or crop your photos as necessary.
5. Choose specific pictures to mat. This is a good way to highlight the importance of a single picture.
6. Add any text you may want included.
7. Add a few extras like wedding napkins, matches, or other relatively flat items.
8. Arrange all items on your pages and adhere them with acid-free, double-stick tape.

One way we have integrated scrapbooking into our wedding albums is by including the sheet music for any special songs that were played at the wedding reception—either the song played for the bride and groom's first dance, or the song that the bride danced to with her father. We simply make a photocopy of the sheet music on a parchment stock, then adhere a picture of the appropriate couple dancing onto the middle of that sheet. The song title and some of the notes are still visible, but the photograph(s) is the main focal point. We have employed this technique in our albums for several years, and it is always popular.

USING IMAGES ONLINE

The Internet is a wonderful way to share pictures with family and friends. Many brides and grooms set up their own personal wedding website, and your digital wedding pictures can make a great addition to their site. You can also choose to post your pictures to your own web site or make one specifically for the wedding pictures you take.

If you plan to post images on the Internet, you will want to consider making the files smaller than the size that came out of the camera. As digital cameras keep capturing more megapixels, the file sizes of each digital picture keeps growing. While these large files are great if you want to make enlargements from your digital pictures, if you load these large files to the Internet they will take a long time to upload and view. For Internet use, the pictures can be resized to 2x3 inches at 72dpi, and they will load easily and not take forever to open. See chapter 7 to learn how to do this.

Another way to share your wedding pictures on the Internet is to have a third-party company host the images online for you. There are numerous companies that can provide this service. A simple Google search will list many of them.

Of course, you can always just e-mail digital pictures to friends and family. Again, I would recommend resizing the pictures to 2x3 inches at 72dpi so that the attached files don't take a long time to upload and open. If your files are too big, many Internet service providers (ISPs) won't be able to handle them or will send your e-mail to the "spam" folder. As a result, the pictures may never be seen. If you are trying to e-mail a number of pictures, you may want to send them in multiple e-mails to keep the file size of the individual e-mails smaller.

One of my favorite online companies for helping with the e-mailing of pictures is Picasa—a free download on Google (www.picasa.google.com). One of the nicest features about this program is that it automatically resizes your pictures for fast and easy e-mailing. This program also catalogs all of your pictures so that it is simple to edit and select the pictures you want to use. In addition, you can create a photo slide show of the pictures you took at the wedding. This one-click operation makes it convenient, and you will look like a pro. What more could you want?

PHOTO ALBUMS

Traditional. Wedding albums are a traditional part of most couples' weddings. There are many commercially available albums to accommodate various sizes of pictures. Better-quality department stores and gift shops will provide you with many options if you want to present your images in an album.

Digital. In today's digital age, it is possible to create digital albums for your pictures. An excellent choice is a company called Shutterfly (www.shutterfly.com). This easy-to-use website allows you to upload your pictures, choose your digital book cover material, choose your page layout, add text, and order the album. The hardcover options are leather, suede, or satin cover materials—each featuring an image in the center of the cover. The soft cover options feature durable photographic paper covers in black, blue, red, green, and a wedding design. The layout options with any of these books allow you to place one, two, or four pictures on a page with the possibility to add captions (text) on every page. With this program you can create a one-of-a-kind, heirloom-quality book that the bride and groom will treasure forever.

OTHER PHOTOGRAPHIC ITEMS

There are a number of other interesting ways to utilize the wedding images you take at your friend's wedding.

One such use of your photographs would be in making photographic calendars and holiday cards. Most office-supply stores and chain stores have

There are many commercially available albums to accommodate various sizes of pictures.

extensive photo departments with numerous product offerings. A calender for the following year with twelve great wedding pictures on it would be a memorable gift to the new bride and groom. Holiday cards are also becoming more and more common. These "slim line" cards feature a 4x6-inch photograph with a holiday greeting and the couple's name. They come with mailing envelopes so that the photograph will not be damaged. After the holidays, many people cut off the "greeting" and simply frame the very nice wedding print to keep forever.

Photographic puzzles are another unusual gift that can be made from your wedding pictures. Many online services offer to make jigsaw puzzles from your digital files. Think of the enjoyment the bride and groom can have building one of their favorite wedding-day pictures!

Still other Internet companies offer to place images on coffee mugs, pillows, blankets, rugs, mouse pads, coasters, etc. These novelty items can add to the couple's remembrance of their special day and will probably be a unique gift—something that wasn't offered by their professional photographer. Shutterfly (www.shutterfly.com) is among the many companies that can provide these products for you.

Photo jewelry is another item that you can consider as a photo gift for your friends. Photo bracelets and watches are a creative way to feature a few of the most treasured wedding snapshots. Again, online companies offer these novelty items at affordable prices. This is also a great idea for the mothers and grandmothers of the bride and groom.

Photographic puzzles are another unusual gift that can be made from your wedding pictures.

CONCLUSION

I hope that reading this text and viewing these images has provided you with some insight for taking better pictures. Like most skills, you will become better with practice. Again, I strongly suggest that every couple hire a professional photographer for their wedding day. Being responsible for recording the once-in-a-lifetime memories of a bride and groom is a sacred trust. Professional photographers have almost no margin of error at the wedding. Every picture is important on this special day. However, the pictures that you, as a guest, take at your friend's wedding can be a wonderful supplement to those created by the professional—and they will provide great memories for the bride and groom and their families.

If you have any questions, please feel free to contact me through my studio's website at www.ricephoto.com. Good luck and happy shooting!

Photographically yours,
Patrick Rice, Master Photographer

AUTHOR AND CONTRIBUTORS

Patrick Rice holds a Bachelors of Science Degree from Cleveland State University, the Professional Photographers of America (PPA) Master of Photography and Photographic Craftsman Degrees, as well as all five levels of Wedding and Portrait Photographers International (WPPI) Masters Degree. He holds the designation of Certified Professional Photographer from PPA and the Professional Photographers of Ohio (PPO) and has received the Advanced Medallion Award from the Ohio Certified Professional Photographers Commission. In 2000, he received the Honorary Accolade of Lifetime Photographic Excellence from WPPI. In addition, he was selected to receive the Photography Leadership Award from the International Photographic Council at the United Nations in New York City. In 2004, Patrick received the PPA National Award for service to professional photography. Patrick has presented programs at both the PPA and WPPI annual conventions and he has authored the following books: *Infrared Wedding Photography* (2000), *The Professional Photographer's Guide to Success in Print Competition* (2003), *Professional Digital Imaging for Wedding and Portrait Photographers* (2004), *Professional Techniques for Black & White Digital Photography* (2005), *Digital Infrared Photography* (2005), and *Digital Portrait Photography of Teens and Seniors* (2005), all from Amherst Media.

Richard Frumkin—Richard's professional photographic career began while he was in college. He was a staff photographer at the University of Cincinnati where he worked on the school newspaper and magazines. At the university, his study of photography helped him to secure assignments as a photojournalist with the Cincinnati *Enquirer*. Rick worked for several leading wedding photography studios before joining Rice Photography. Rick has won several awards for his images.

Travis Hill—Travis holds PPA's Master of Photography and Photographic Craftsman degrees and was one of the association's youngest recipients of these honors. He also holds the Accolade of Lifetime Photographic Achievement from WPPI. He has earned the degree of Certified Professional Photographer from both PPA and PPO. He was a speaker at the PPA Annual Convention in 1999 and WPPI in 2003 and has lectured to audiences both large and small across the country. His images have been selected for inclusion in the PPA Loan book, PPA Gallery book, and the WPPI Annual editions. Travis is coauthor of *Infrared Wedding Photography* (2000), by Amherst Media.

Anthony Zimcosky—Anthony (Tony) Zimcosky is a native of Cleveland, Ohio, who has worked at Rice Photography for over seventeen years. His work has won numerous awards in print competitions.

INDEX